IMAGES
of America

WESTERVILLE

*Thanks for your interest
in Westerville history*

Bill Wernhout

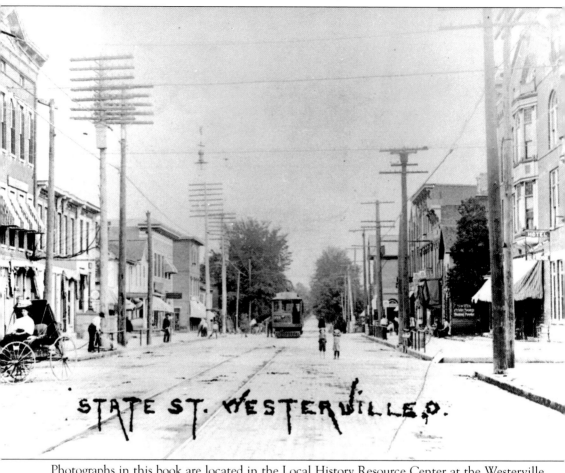

STATE ST. WESTERVILLE, O.

Photographs in this book are located in the Local History Resource Center at the Westerville Public Library, 126 S. State Street, Westerville, Ohio.

IMAGES
of America

WESTERVILLE

Beth Berning Weinhardt

ARCADIA
PUBLISHING

Published by Arcadia Publishing
Charleston, South Carolina

Printed in the United States of America

Library of Congress Catalog Card Number: 2003115858

For all general information contact Arcadia Publishing at:
Telephone 843-853-2070
Fax 843-853-0044
E-mail sales@arcadiapublishing.com
For customer service and orders:
Toll-Free 1-888-313-2665

Visit us on the Internet at www.arcadiapublishing.com

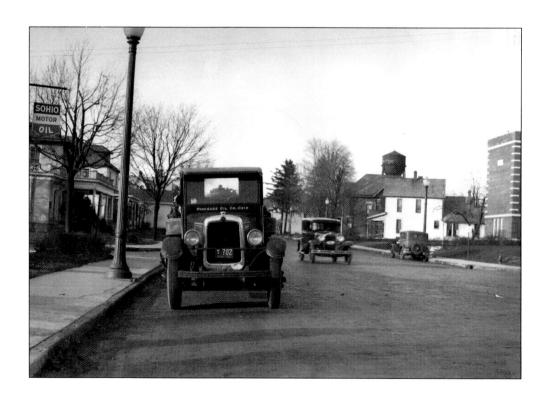

CONTENTS

ACKNOWLEDGMENTS

The Westerville Public Library's board and library director Don Barlow have a commitment to preserve Westerville history and make it readily available to the public at the library. For the past decade I have had the good fortune to work as local history coordinator in the Westerville Public Library's Local History Resource Center and Anti-Saloon League Museum. Through the Westerville Historical Society I have gotten to know many Westerville residents, old and new, and been thrilled when items are added to the local history collection through their efforts. A special thank you to everyone who has helped the collection of facts and artifacts grow.

Thanks go to Belinda Mortensen, Linda Wilkins, Tonya Taylor, and Kristin Kauffman for proofreading, technical assistance, and moral support on this project.

Finally I would like to thank my family: my husband, John; my children, Laura and Alex; and my parents, Bob and Doris Berning. My mother instilled in me a love of libraries, and my father modeled a strong work ethic for me.

INTRODUCTION

According to the 2000 United States census, Westerville is the largest suburb of Columbus, Ohio. The community spreads through northeast Franklin County and into Delaware County. Gone are the days when a round trip to Columbus from Westerville required a half-day. This book of photographs of the community gives us an opportunity to look back at what was, and hopefully provokes some thoughts about where we are going. It covers the history of the community from 1806 when the first settlers arrived in Blendon Township, to 1961 when Westerville became a city. The photographs span from the 1860s to the early 1960s.

The history of Westerville is exceptional. Chosen as the site for the printing headquarters of the Anti-Saloon League in 1909, the town became known throughout the United States and abroad. Emissaries from the World League Against Alcoholism, an offshoot of the League headquartered in Westerville, traveled the world spreading the anti-alcohol message and the town's reputation as the "Dry Capitol of the World." Few towns of Westerville's size can boast a similar impact on the country's history.

The citizens of Westerville were diligent in their pursuit of opportunities to make their community a better place. Beginning with the successful campaign to attract Otterbein College to Westerville, savvy residents have used the means at their disposal to bring about worthwhile changes in the town. The enticement of the Anti-Saloon League to the town was the pinnacle of citizen efforts. Time passed and the League's influence on the country and the community is a faded memory. However, much of Westerville is still "dry" today.

For nearly 200 years Westerville grew and changed like so many other small communities across the country. The "quiet, peaceful village" referred to in the Otterbein alma mater was typical of other communities of its size in the 19th century. The 20th century improvements in transportation, revolutionizing the way Americans lived and worked, brought changes to Westerville. The growth pains experienced by communities across the country were also felt locally.

In 1906 at a centennial reunion of the arrival of the Griswold and Phelps families in the Westerville area, one of the descendants spoke about the sacrifices of the first settlers. Mrs. Minerva Griswold Westervelt said of them, "Since then one hundred years have passed. Can it be? These happy golden years have glided o'er us on such swift silent wings, that we fail to realize their coming or going. But to-day we realize more fully . . . the debt of gratitude we, their descendants, owe to those dear, brave, unselfish hearts who breasted the perils and hardships of a wearisome journey of eight weeks overland in an ox cart, only to be met by greater perils at their journey's end."

The descendants of those pioneers and countless others who followed them have built a community rich in heritage and endless possibilities for its future.

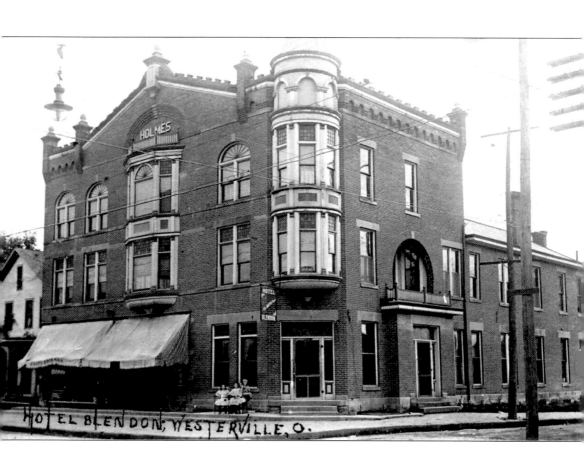

One

THE LAND AND THE FIRST SETTLERS

Thirty-three years after her arrival in this untamed land, Azubah Phelps, one of the first settlers in the area, wrote a letter to her brother in Connecticut describing her pioneer life. She wrote, "It was a great undertaking to leave our native state, our relatives and friends, and go such a long distance to this then wilderness of Ohio, never more to see those relatives and friends. We settled down here, cleared up the land; the soil was rich; we have lived well, but there has been a great desire to see the old home and relatives."

Edward Phelps, Azubah's husband, was 46 years old when they loaded their belongings into a wagon, took their children by the hand, and left Windsor, Connecticut for the heavily wooded lands in Central Ohio. Why undertake this journey filled with an uncertain outcome? Azubah answers that question when she writes, "This is a rich land. Our children are better off than if we had remained at Windsor."

The Griswold-Phelps migration was followed by the arrival of the Sharps, Timothy Lee, Gideon Hart, and the Westervelts along with many others through the years. They came for a better life for themselves and their families. Westerville fulfilled that dream as the pioneers carved a fine community out of the wilderness with hard work and vision.

The banks of Alum Creek were attractive to the first settlers who came to the Westerville area. Arriving in oxen-drawn wagons, they camped near the creek. Rich land for their farms and rushing water to power their mills fueled dreams of a better life for their families in Central Ohio. The arduous trip from the homes they left behind in the east to this unsettled land took two months.

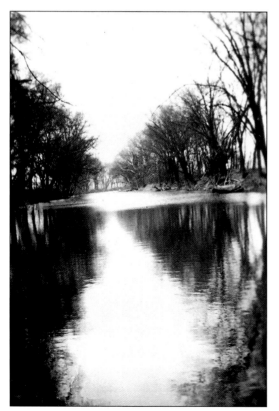

When the first settlers arrived from Windsor, Connecticut, Native Americans were camping on the banks of Alum Creek. Attracted by an abundance of wildlife, they pitched their teepees near the creek. Today evidence of their presence on the land remains. Arrowheads, striking stones, and other handmade tools can be found on the banks of the creek.

Settlement grew in the area between the banks of Alum Creek and Big Walnut Creek. Big Walnut Creek attracted the attention of Timothy Lee, who built a log cabin on its banks. Lee later built a grist mill, saw mill, woolen factory, distillery, and this large family home on the creek. The area known as Central College was developed because of his efforts to build an institution of higher learning in that community.

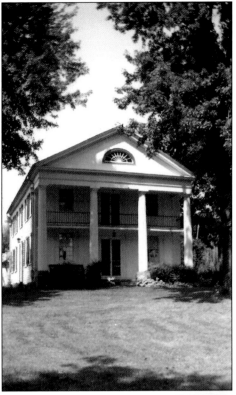

The land was gradually cleared to make way for farmers' fields and grazing pastures. Endless toil on the farms dotting the landscape led to scenes like this, with fences dividing the land. The early economy was based on agrarian pursuits and barter, with little actual money changing hands. Azubah Phelps wrote in 1839, describing this system, "We trade something that we raise to the storekeepers for what we buy at the stores."

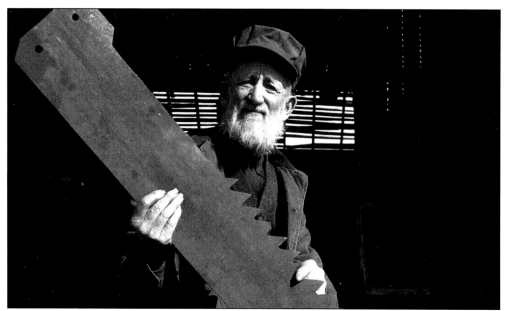

William C. Phelps is pictured here holding the saw blade of his great grandfather Gideon Hart who operated a saw mill in 1817. Hart, a respected early settler, was a veteran of the War of 1812. His father served in the Revolutionary War, and his widow, Gideon's mother, was awarded 150 acres of land in Blendon Township, which Gideon claimed and added to until he owned 380 acres. Gideon Hart's home, one of the oldest structures in the community, still stands on Hempstead Road.

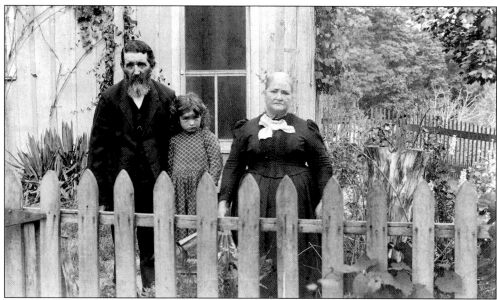

Eunice Maria Lewis Brown, on the right, with her granddaughter Helen B. McLeod in the middle, and her husband William on the left, described the pioneer life of her family. Her grandfather, David Lewis, came to Delaware County to build a new life. Eunice writes of the pioneer diet in those early years, "For a few years their living was mostly corn bread or some form of corn in meal or hominy, and pork, with wild game, which was plentiful, even deer and wild turkey."

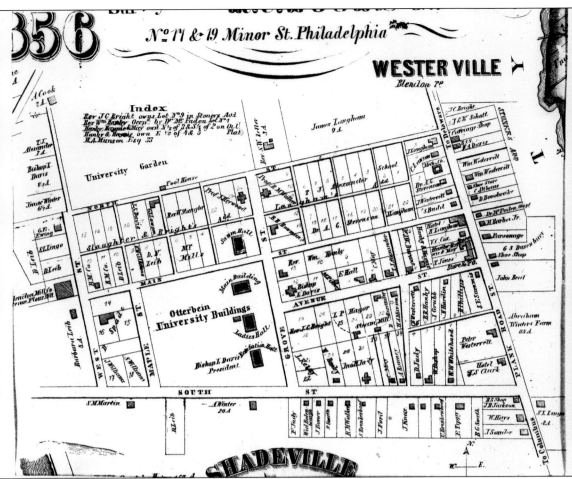

By 1856 the village had been platted and a college founded through the efforts of the Westervelts, early settlers from Dutchess County, New York. The citizens rewarded the philanthropy of the family by naming the first post office Westerville and thus naming the village. This early plat map shows the plank road from Columbus to Delaware passing through the village with businesses springing up along the route and creating the forerunner of the uptown business district still in existence today, with its 19th century buildings lining State Street. One writer from the era states, "Westerville is becoming an attractive village. Every year new streets are laid out, new walks made. . . . The bark is in the ascendant now, but it is soon to be supplanted by brick." The population in 1840 was under one hundred with two or three stores and one church. By 1858 the population was 275 with businesses emerging to serve the citizens and the 267 students at Otterbein University.

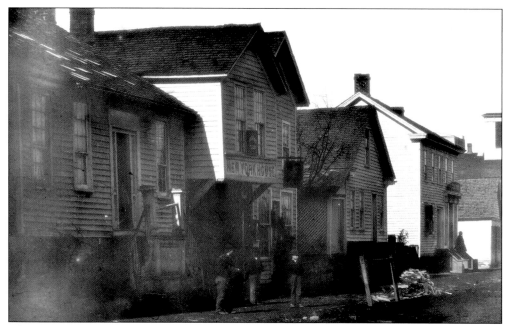

This is one of the earliest photos of the uptown business district. The Methodist Church is in the background. Frame structures lined the muddy street. From humble beginnings a village was emerging, with commercial buildings mingling with residences on State Street. The image dates to around 1860. A visitor to the village commented, "The contrast between Westerville of 1849 and the Westerville of 1859 is great. The Westerville of '49 was a dingy, swampy, beggarly village, glorying in a single painted dwelling house. . . . The Westerville of '59 abounds in tasteful residences."

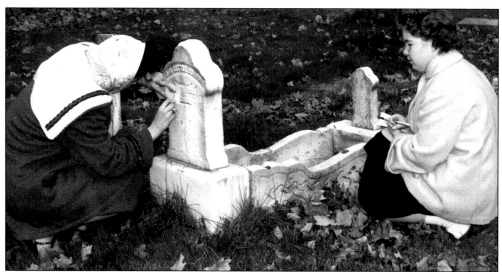

The pioneer phase of Westerville brought much hardship and heartache to families. In Pioneer Cemetery three Schrock graves lie together and tell a horrendous story. Ephraim Schrock, age 21, died December 9, 1834; Matilda Schrock, age 15, died December 20, 1834; and Nancy Schrock, age 24, died December 26, 1834. William Schrock Jr. and his wife Elizabeth lost three children in several weeks time. These students are studying the grave of a child in Otterbein Cemetery.

Two

CITIZENS TAKE
A STAND

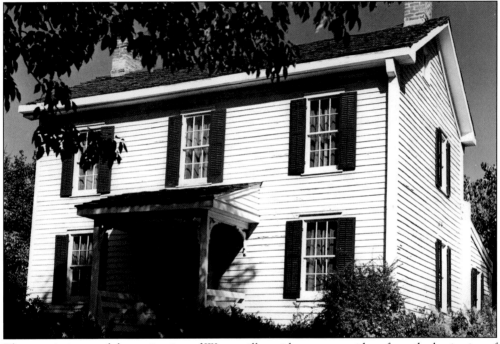

The convictions and determination of Westerville residents were evident from the beginning of the community. In the fervor of a religious camp meeting, the settlement residents petitioned the Methodist Church for permission to open a religious academy. The settlement had no name and less than a hundred residents, but the strong convictions were already evident that would lead them to embrace abolition of slavery and prohibition of alcohol.

In the 1850s, while the country was struggling with the slavery issue, many Westerville residents were risking their freedom and family finances to aid runaway slaves. The Hanby family, the Lewis Davis family, George Stoner, Thomas Alexander, and the Sharp family were all involved in transporting and hiding fleeing slaves. Barns, attics, cellars, and even wooded areas served as shelter for the fugitives. The strong abolitionist sentiments of those involved were matched by their actions.

Westerville gained notoriety in the 1870s with a series of saloon bombings that became known as the "Westerville Whiskey Wars." The strong "dry" reputation of the community was one of the factors that persuaded the Anti-Saloon League to locate their national printing center and headquarters in the town. Founded in 1895, the Anti-Saloon League was a non-partisan, temperance organization whose sole mission was to eradicate the saloon and liquor traffic. With their arrival and the printing of tons of anti-alcohol information, the small town of 2,000 became known as the "Dry Capital of the World."

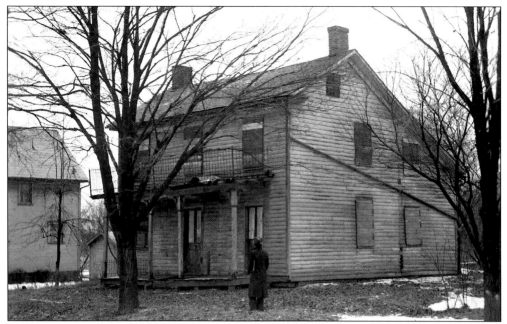

The Hanby House, pictured here before being moved and restored, was a symbol of the strong anti-slavery feeling in Westerville in the years before the Civil War. William Hanby, owner of the home, was a bishop in the United Brethren Church and was a conductor on the Underground Railroad both in Westerville and in his previous home in Rushville. Hanby had served as an indentured servant to a cruel master before fleeing to Ohio where he made a new life and became part of the network to help runaway slaves.

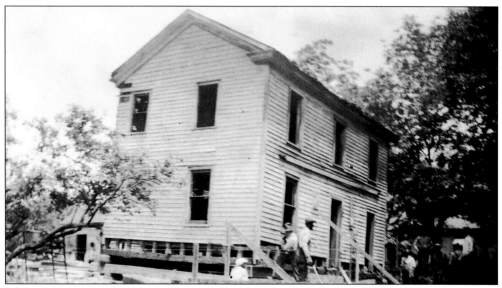

William Hanby and his neighbor Lewis Davis worked together to hide runaway slaves. Both owned homes on Grove Street (where the Church of the Master and Otterbein's Clippenger Hall currently stand). The runaways were hidden in the Hanby barn until nightfall when, under the cover of darkness, they were taken into one of the houses for an evening meal. The Hanby House was moved twice before it ended up at its current location.

Ben Hanby came to Westerville to attend Otterbein and became one of its most famous residents. He composed the popular Civil War ballad "Darling Nelly Gray" and the holiday favorite "Up on the Housetop." "Darling Nelly Gray" was based on a true Underground Railroad incident that a dying runaway slave, Joe Selby, shared with William Hanby. Ben Hanby heard the tale of the separated slave couple when he was nine years old. Ten years later he turned it into one of the most popular musical pieces of his day.

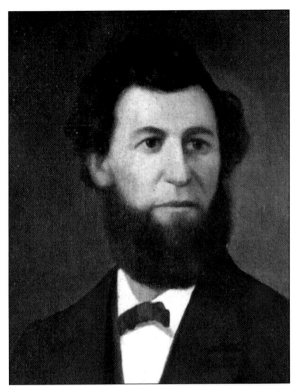

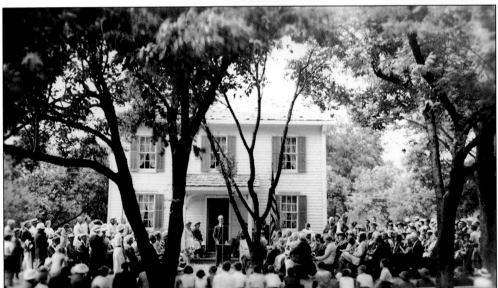

On June 13, 1937, Brainerd O. Hanby, son of Ben Hanby, stood on the steps of the restored Hanby House on West Main Street and helped dedicate his ancestral home as a museum. The nearly 500 people in attendance were there to honor William and Ben Hanby and the contributions they made to the abolitionist cause. Ben was a prolific songwriter with strong convictions about the social issues of his day. His composition "Terrible Tough" tackled the Civil War recruiting problems in Ohio, and his song "Little Tillie's Grave" spoke of the evils of slavery. Ben Hanby died in 1867 at the age of 33, leaving behind an extensive collection of work.

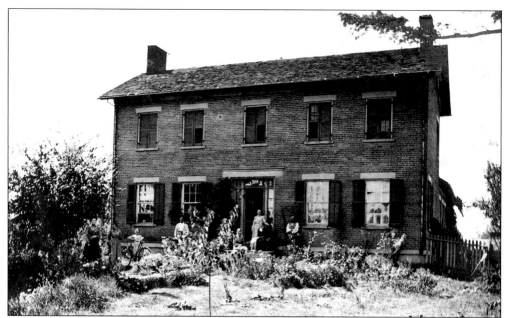

Built in 1849 by Gerrit Sharp, this home was a station on the Underground Railroad. On the north end of town, it was built with bricks fired on the property and a foundation aligned to the North Star. Gerrit Sharp and all of his sons helped runaway slaves hide on their flight to freedom. Several of the sons' homes still stand in the vicinity, as well as this building.

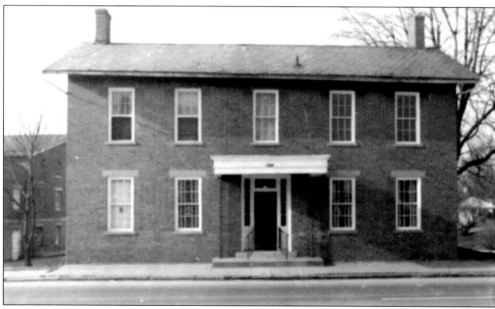

George Stoner, owner of this inn, was a stagecoach driver bringing passengers on the two-hour trip from Columbus to Westerville. In the 1850s his passengers traveled in his coach along the muddy road to the inn on the south end of Westerville. His hidden "cargo," in the luggage compartment of his coach, was runaway slaves. These fugitive passengers were hidden in his cellar or near the wooded pond in his backyard until they could be moved farther north on their way to Canada and freedom.

Westerville passed an ordinance in 1859 that forbade the sale or barter of alcoholic beverages. The community of people with strong convictions embraced the anti-alcohol cause. In the 1870s businessman Henry Corbin attempted twice to open a saloon in Westerville. Both saloons were dynamited. The aftermath of the explosion at his second attempt is pictured here. This building was located on the east side of State Street and was torn down after the explosion.

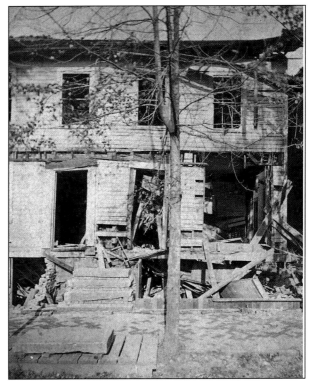

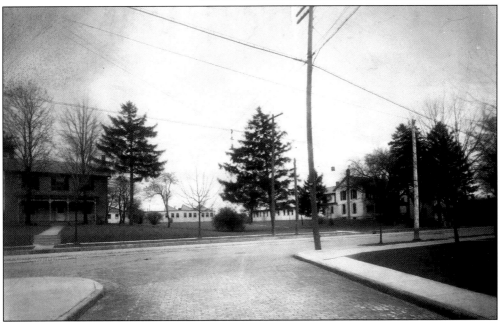

In 1909 the people of Westerville raised funds to purchase a home and property on South State Street (the current site of the Westerville Public Library) with the intent of luring the Anti-Saloon League to locate their national printing center in the town. The brick house on the left housed offices for the national organization of the League and its printing operation. The building in the background, with the unusual roof, housed the printing operation.

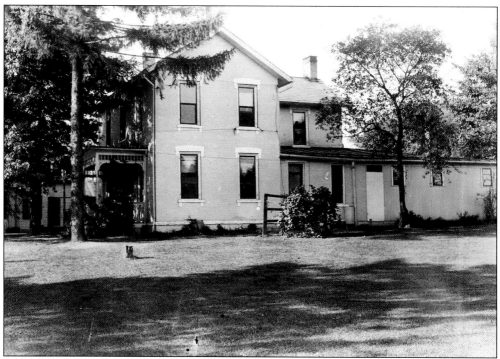

The headquarters building was originally a private home built in the 1850s by George Stoner. The Anti-Saloon Leaguers directed a national campaign for a prohibition amendment from this site. Their lobbying efforts and the printed material that flowed from Westerville resulted in the 18th Amendment to the Constitution.

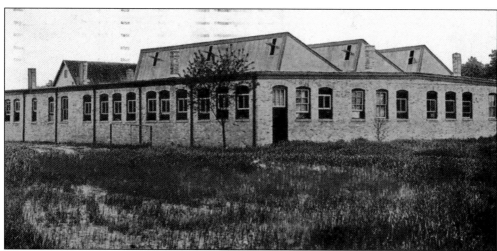

An ocean of anti-alcohol information flowed from this American Issue Publishing Company. Newspapers, fliers, and posters all made the case for a "dry" America. The business had state-of-the-art equipment for printing and packing the material for shipment. A decade after the flow of information began from this Westerville printing center, the country went dry with the passage of the 18th Amendment to the Constitution.

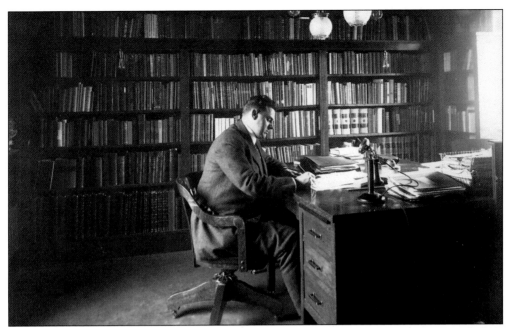

Ernest Cherrington, editor of most of the Anti-Saloon League's publications, worked at his desk surrounded by his extensive library in the headquarters building. The temperance material he collected and produced eventually filled the building. These materials comprise the largest temperance collection in the world. To honor his contribution to the country's history, Westerville named a street, school, and park after him.

The League's publications and lobbying efforts were forerunners of modern marketing campaigns. This poster highlights two of the appeals they used to attract people to their cause: protection of youth from the evils of alcohol, and patriotism. Their crusade was aided by World War I when they made the case that the resources used to produce alcohol should be used for the war effort. Wayne Wheeler, one of the leaders of the League, stated, "Kaiserism abroad and booze at home must go."

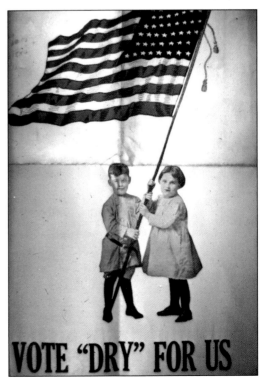

The leadership of the League moved to town along with their group's printing headquarters. This produced a minor building boom south of the college along Grove Street, which became known as "Temperance Row." The people employed by the League in its printing center and the revenue generated by the League's activities were a boost to the local economy. Taken outside the American Issue Publishing Company, this is a photo of members of the staff. League leaders are in the front row center of the photo.

Anti-Saloon League leaders became an integral part of the leadership of civic organizations and churches in the community. H.B. Sowers, pictured with his wife, daughter, family friend, and family dog, is proudly showing off his 1921 prize-winning, local parade entry. Sowers was treasurer of the League and served as a board member of the Westerville Public Library from 1930 to 1949.

Three

EDUCATION

Education has been an important part of life in Westerville from the days when students attended one-room schoolhouses to today when the school system includes sixteen elementary schools, four middle schools, and three high schools. Recognizing the importance of education for their children, the first pioneer families set up a school in the Griswold log cabin and then in the Phelps barn. As more settlers arrived, six one-room schoolhouses were built throughout the area. These buildings were functional, not fancy.

By the mid 1850s citizens decided to build a school in the village. A one-room brick school was built on West Home Street. By the start of the Civil War the school was integrated. The early school board minutes give us a glimpse into education 1865-style. In that year the four female teachers in the school were paid $1 per day, and the female principal was paid $1.25 per day. The total budget for the school year was $700.

Otterbein came to Westerville because the citizens wisely saw an opportunity to use the grounds of the failed Blendon Young Men's Seminary for another institution of higher learning. Otterbein opened its doors on April 26, 1847. Its arrival in the village was one of the most important events in Westerville history.

Otterbein was one of the first co-educational colleges in the nation and one of the first to open its doors to students of color. Through the years Otterbein graduates have established their worth in many fields of endeavor.

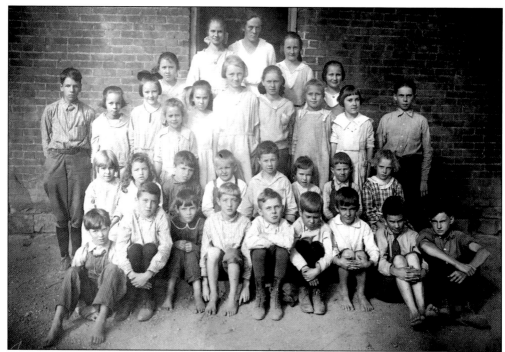

Students in this photo attended one of the many one-room schoolhouses in the area. The busy teacher was responsible for the education of eight grades of students in one room. Note the bare feet of some of the students. One school had an unofficial competition each spring to see who could be the first to attend school minus their shoes. In the 19th and early 20th century most young people in the area were educated in this type of country school, coming into town only if they were privileged enough to attend the high school.

The Harbor Road School was on Cleveland Avenue. Students at a reunion recalled attending school in the building. They shared memories of the "drinking fountain"—a bucket with water drawn from a well and a common cup for all to share; the "library"—a bookshelf in the back of the room; and the "lunch program"—a pot of rice cooked on the stove by the teacher and ladled out for each student.

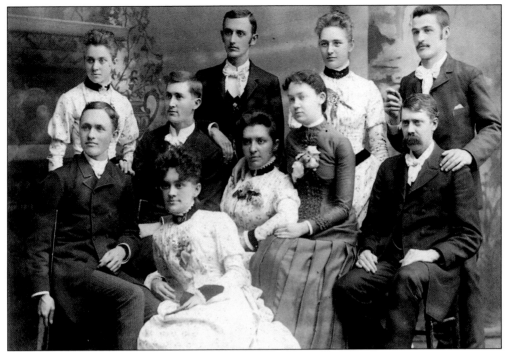

This photo was taken in the junior year of the Westerville High School class of 1889. The year 1889 was the first that a three-year high school course of study was offered in the Westerville schools. Students attended the Union School, a brick schoolhouse located on the east side of Vine Street between East Main Street and Home Street. The Union School was built in 1867 with a levy of $5,000.

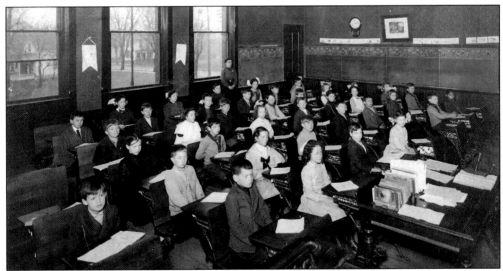

The Union School became terribly crowded, and the citizens of Westerville approved a levy to build the Vine Street School. The Vine Street School cost $20,000 to build and is still in use as Emerson Elementary School. When built, it housed all grades—first through high school. In the early years rural students who attended the high school arrived on horseback. Some spent the week in Westerville returning to their homes only on weekends.

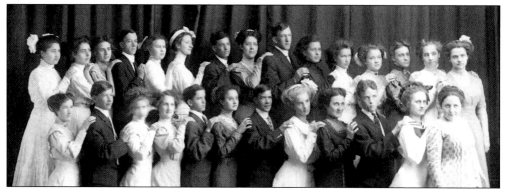

By 1910 when these 27 students graduated, the high school curriculum at Vine Street School was a four-year course of study. The six-room school had been enlarged with an addition of four rooms. The outside bathroom facilities had been moved inside. At the beginning of the school day students marched into the building to a piano tune played by a teacher or student. The playground was segregated, with one side for the boys and one side for the girls with a fence down the middle.

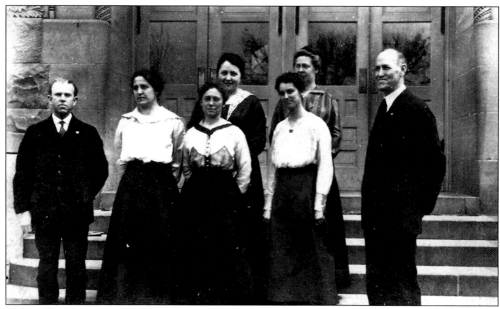

The staff at the Vine Street School posed on the steps of the building in this photo taken before World War I. Superintendent Warson, on the right, was paid $200 per month. Salaries for the teaching staff ranged from $25–$85 per month. Generations of Westerville students have marched through this distinctive front door to attend school taught by dedicated educators.

Classes at the Vine Street School became so crowded and facilities so outdated that the school's accreditation was withdrawn in 1921. That was a signal to the community that the days of all grades being housed in one school building were at an end. The community was growing, and the schools had to keep pace. This large class posed with their teacher in front of the school.

A bond issue of $190,000 was passed to erect a new junior-senior high school on State Street. Containing both a gymnasium and an auditorium, the new building had classrooms for agriculture, home economics, and typing. Students attending the school were being prepared to take their place in the local economy.

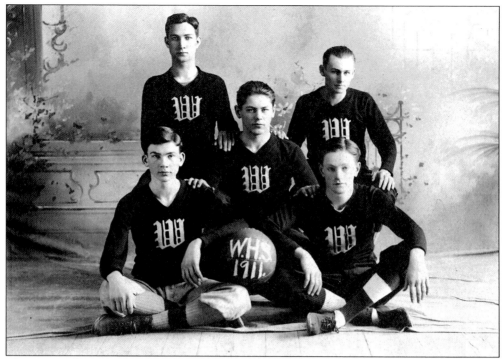

The Westerville schools provided opportunities for students to participate in many activities. This 1911 basketball team scored as low as 13 points in a game and as high as 76 points. The 13 points were in the first game of the season and the 76 in the second to last game. The all-senior team showed vast improvement in their skills as the season progressed.

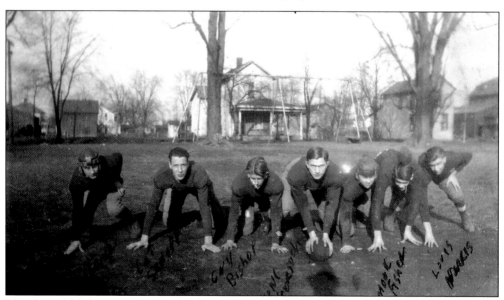

This formidable line is practicing football on the Vine Street School playground. Team members are, from left to right, Bill Frazier, Catfish Seneff, Guy Bishop, Gene Gorsuch, Charles Lambert, Monk Fisher, and Louie Norris. All wore shoulder pads, but helmets appeared to be optional in the photo. Football games were an all-community event for many years.

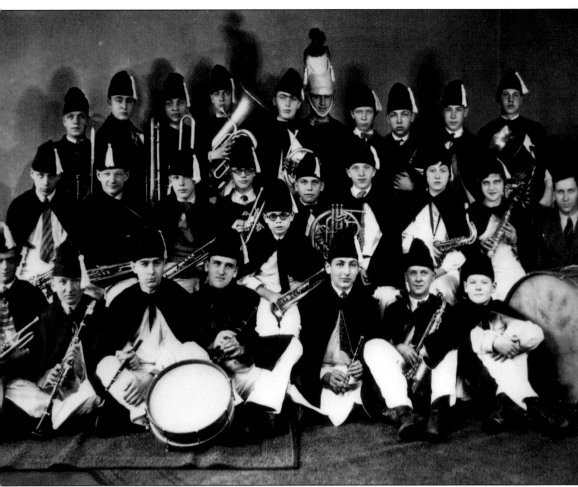

Westerville High School's first marching band posed for this photo. Organized in 1926, the band, directed by Rod Shaw, included two female members. The black felt capes and hats worn by the band members were sewn by their mothers in an effort to cut costs. Rollie Freeman, the drum major, had a distinctive, purchased shako hat. These are the members: (front row, left to right) W. Krebbs, (unknown) Hanawalt, D. Euverurd, J. Harris, (unknown) Harris, M. Cornell, and N. Alexander; (second row, left to right) E. Ricketts, L. Breden, J. Dew, E. Burtner, F. Nutt, J. White, W. Shelley, R. Freeman, D. Schrader, and Rod Shaw; (third row, left to right) A. Schrader, D. Wylie, D. Charles, A. Alexander, R. Keyes, R. Freeman, (unknown), R. Furber, R. Johnson, and C. Patton.

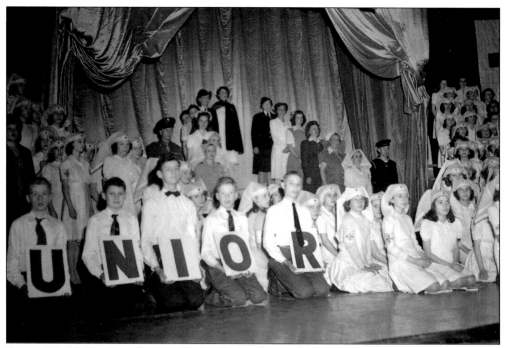

During World War II students in the local schools raised funds for the war effort and displayed their patriotism with this Red Cross program. Staging their pageant in the high school auditorium, students wore garb honoring every branch of the armed forces and the Red Cross.

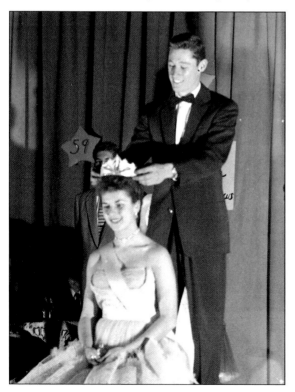

Formal dances were enjoyed by the students in the 1950s. In this 1956 photo Barbara Dixon is being crowned winter homecoming queen by John Worley. In earlier years "pushes" were informal parties held by the students. Just as exciting but less organized than the later dances, the "pushes" usually involved some marching around town, with students singing and yelling their class cheers before gathering for refreshments at a classmate's home.

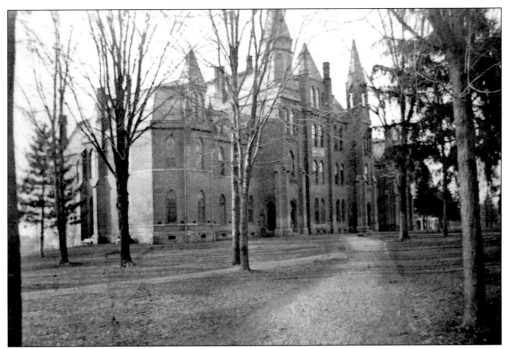

Founded in 1847 on the ground of the failed Blendon Young Men's Seminary, Otterbein University brought students, their families, new businesses, and a sense of identity to the small village. An institution of higher learning under the auspices of the United Brethren Church, Otterbein graduated its first two students in 1857, both women: Kate Winter and Jenny Miller.

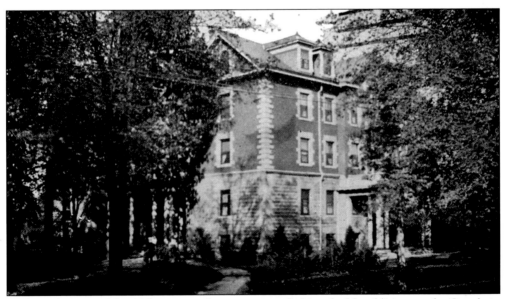

In the early years of the 20th century, donations provided invaluable additions to the Otterbein campus: from Andrew Carnegie for a Carnegie Library; from George Lambert and family for Lambert Hall; and from Sarah Cochran for this building, a dormitory for women. Fund-raising campaigns in the early years of the 20th century placed Otterbein on firm financial ground, with some help from generous local citizens.

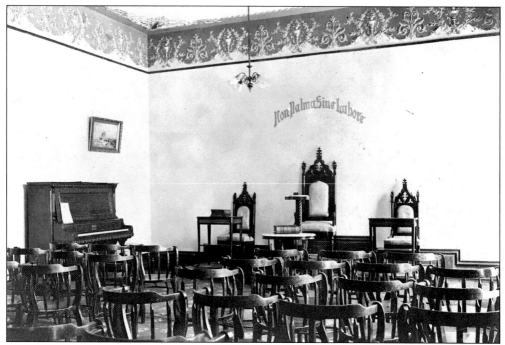

Students at Otterbein organized four literary societies in the first decades of the college. In 1871 when Towers Hall was erected, these societies—two for men and two for women—were each given their own special room. The societies, always in competition, decorated their spaces in elaborate fashion. They conducted programs of speeches, debates, and music on a regular basis.

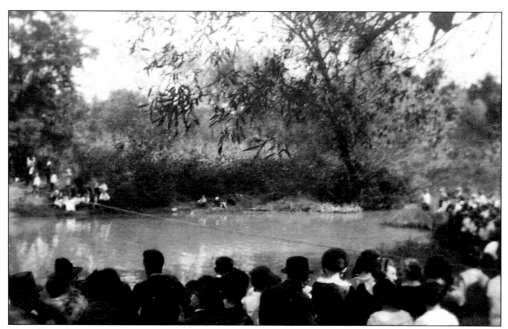

Not all student life revolved around literary pursuits. In this photo students are cheering on their favorite team to win a tug of war held on the banks of Alum Creek. In the early years of Otterbein strict rules of conduct governed the students, especially in the relationships between the sexes.

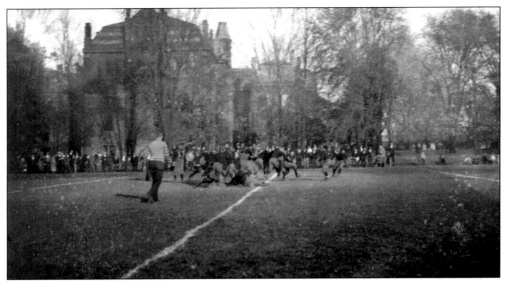

Sports were an important part of Otterbein campus life. This 1912 football game is on the old field adjacent to Towers Hall. Otterbein fielded a baseball team in the 1870s and turned its sports prowess to football in 1889. In the first game of the 1891 season Otterbein beat Ohio State University with a score of 42 to 6!

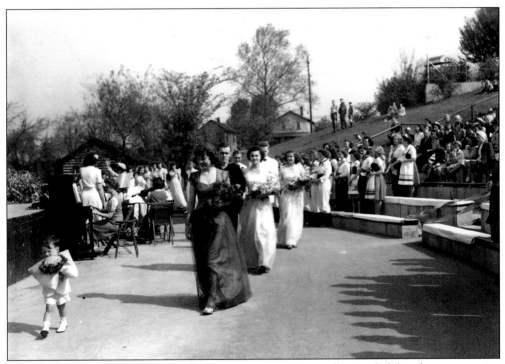

Cultural and educational events held on campus were well-attended by the community. Citizens went to lectures, musicals, and plays sponsored by the college. In this photo the 1944 Otterbein May Day Court, dressed in formal attire, entered the Alum Creek Amphitheatre led by a young boy carrying the crown for the May Queen. Many Westerville residents looked forward to these annual festivities.

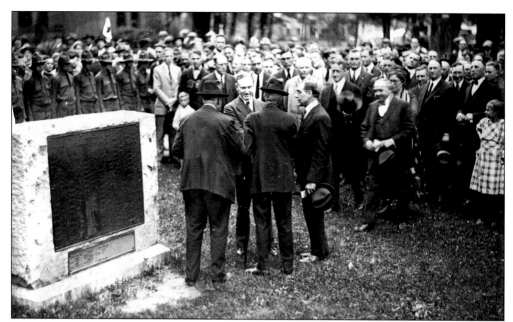

May 11, 1922, the Otterbein campus was the scene of a special ceremony when Calvin Coolidge (in the center of the photo, facing the camera) dedicated a monument to the honor of the young men from Otterbein who served in the Civil War. The monument, which is located in front of Towers Hall, lists names of the Civil War soldiers from the College. Through times of war the college enrollment decreased as students answered their country's call to arms.

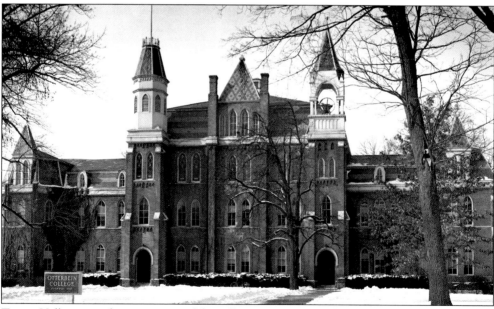

Towers Hall remains the centerpiece of the college campus. It stands as a testimony to Westerville's connection to Otterbein. In 1870 when the main college building that contained the library, science labs, and numerous classrooms burned to the ground, many citizens were fearful that the school would move to Dayton. In an effort to keep the school in their community citizens raised $25,000 to replace the ruined building. Towers Hall rose in its place and Otterbein stayed.

Four

GOVERNMENT

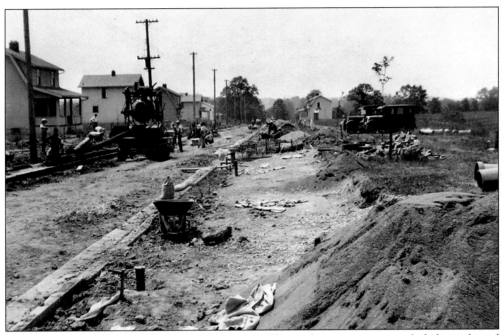

On July 19,1858, Westerville was incorporated. The early government included an elected mayor, recorder, and five trustees. Three of the positions in the first election were filled by Otterbein professors, including the mayor—Professor John Haywood. The early ordinances enacted by this group of men give us some clues about why Westerville was called a "quiet, peaceful village." Ordinance VI states than any person or group of persons with "bells, horns, pans, kettles, drums" shall be fined not less than $30 by the mayor. They also passed an ordinance making Westerville "dry."

Many of the early ordinances dealt with fire protection, including one in 1860 that founded the first volunteer fire company. The health of the residents was also of concern. So in 1886 a health department was created to regulate the roaming of horses, cattle, and hogs through the streets unattended and to regulate the location of privies.

In 1916 Westerville became the first village in Ohio to adopt a city-manager style of government. Today the city hires a manager to handle the day-to-day operation of the city. A city council of seven members is elected and is non-partisan. They choose from their ranks a mayor who primarily serves a ceremonial role.

By the 1950s Westerville had a police force of five men, a volunteer fire department, its own water purification plant, its own electric department, and a municipal park run by a recreation board. Today a professional fire department and a parks and recreation department have been added to serve a community that has grown in population, and also in land through annexations.

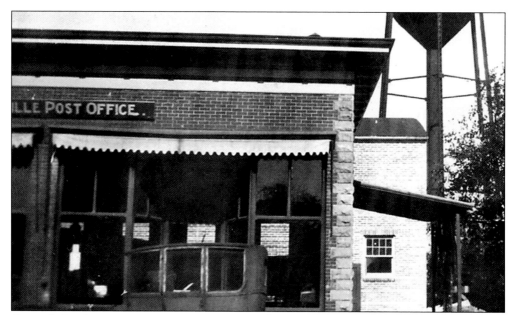

One of the first government institutions in the community was the post office. When Westerville was being settled, citizens had to collect their mail at Blendon Four Corners, at the juncture of Westerville Road and Dublin Granville Road (Highway 161). By 1840 the residents of Westerville petitioned for their own post office and settled on Westerville for the name of the new post office. The post office building in this 1920s photo was on East College Avenue.

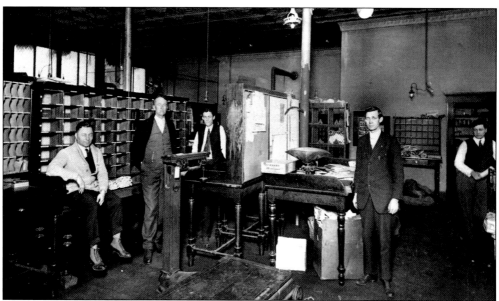

These post office employees worked at the East College Avenue post office. Pictured from left to right are Carmel Demorest, Postmaster Frank Bookman, Leslie Nafzger, Phillip Luh, and Jess Bean. They were part of a postal operation that became significant after 1909 when the Anti-Saloon League located its printing headquarters in the village of Westerville. Because of the volume of mail generated by the League, Westerville had the largest first class post office for a town of its size in the United States.

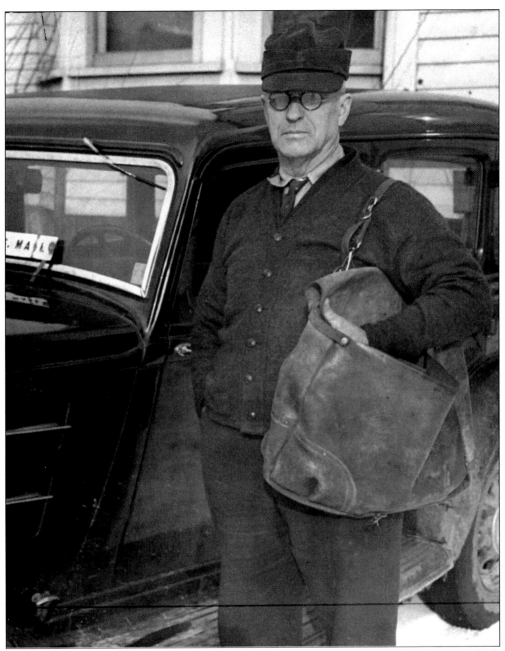

In the early years of Westerville, residents picked up their mail in the general store, which housed the post office. Harry McElwee was one of the first postal employees to have a city route and deliver mail to residents at their homes. McElwee was a postal employee for 42 years from 1916–1958. He is pictured standing by the vehicle he used for rural mail delivery. Driving through the country roads, he made a 50-mile trip daily delivering mail in the Westerville vicinity. Rural delivery was launched in 1902 after a petition requesting the service was signed by 300 residents over a 32-mile route. Perry Yantis served as the first rural carrier.

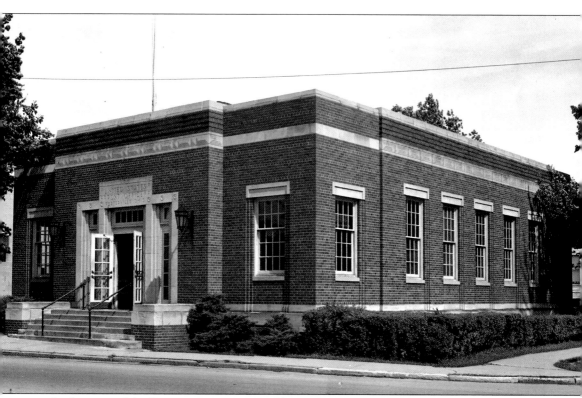

In the years of the Depression numerous public works projects turned the country's unemployed workers into wage earners. The construction of this new post office at the northeast corner of State Street and Winter Street was one of those projects. The square brick building was constructed in 1935. One aspect of the building's interior was controversial. Olive Nuhfer, an artist commissioned by the Works Progress Administration, created a mural that was hung in the building. It showed residents in an area more urban than Westerville going about their business. Olive Nuhfer was from Pittsburgh and never visited Westerville. Upon viewing the mural residents recognized that it did not depict their pastoral community and expressed their displeasure.

Westerville was incorporated in 1858 when 87 residents signed the petition for incorporation. This marker was the gateway into the community in the 1950s—100 years later. The community grew from a sleepy village to a thriving town on its way to becoming a city.

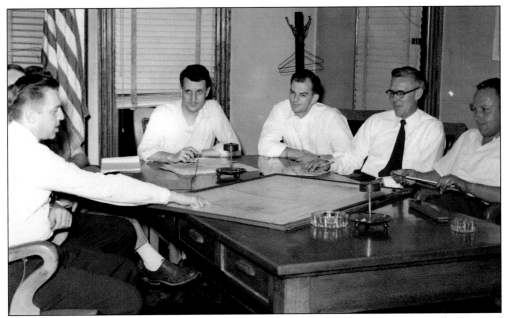

Westerville adopted the city-manager form of government in 1916. In this effective and efficient form of government citizens elect a city council that in turn hires a city manager to handle the day-to-day operations of the city. In this 1950s photo, City Manager Ralph Snyder points out an area of interest on a plat map at a meeting in the city building.

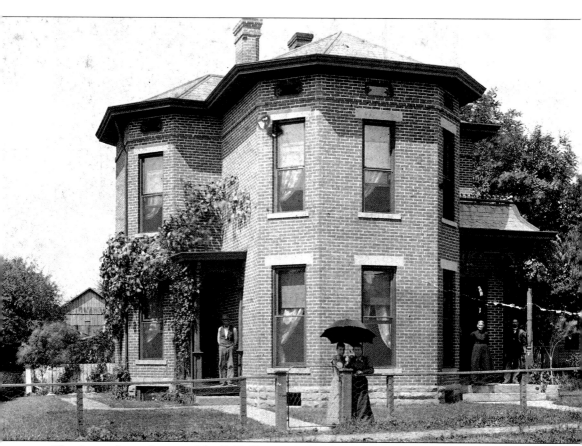

The home formerly owned by B.T. Davis on South State Street was purchased from the Methodist Church by the City of Westerville for $4,300. The purchase in February 1933 came when the citizens of Westerville were reeling from the impact of the Bank of Westerville failure and layoffs of workers in all sectors of the local economy. City Manager Ross Windom arranged for workers remodeling the home into city offices to be paid with funds from the federal government. Of the skilled and unskilled workers laboring on the project, the plumbers were paid the most, earning a dollar an hour. The unskilled laborers earned only 35¢ an hour.

The renovated building housed city offices on the first floor, the Westerville Public Library on the second floor, and the fire equipment for the town in the rear of the building. The brick for the additions and modifications to the original Davis home came from the former city hall. It was located on East Main Street and was demolished.

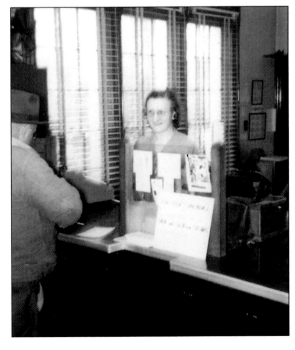

Long time city employee Mildred Tedrow assisted customers in the offices on the first floor of the city building. Walter Shelly is in the background talking on the phone. Citizens paid their utility bills in person at Miss Tedrow's window. Face-to-face service was the norm in the small town during the 1930s, 1940s, and 1950s, before rapid growth began.

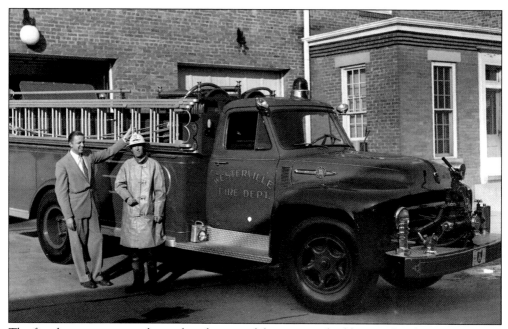

The fire department was relocated to the rear of the new city building on South State Street. It was an all-volunteer department for over 100 years. This fire truck, admired by City Manager Ralph Snyder on the left and Floyd Freeman on the right, was a vast improvement over the horse-drawn cart with ladders and hose that answered the fire bell in the 1870s.

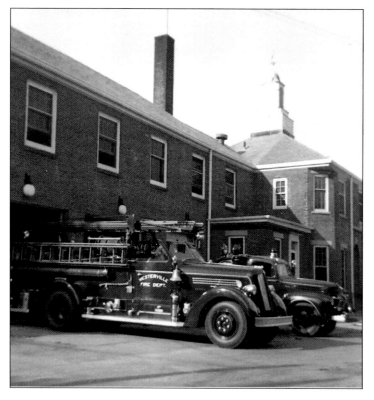

The fire department added an area for lodging at the back of the city building. Otterbein students were recruited to act as firemen in exchange for room and board. This helped the city as the population grew, since the department was still all volunteer. It was not unusual to see one of these Otterbein firemen dash out of class when the fire alarm sounded, hastily don fire hat and coat, and speed off in pursuit of the blaze.

Hired as a night watchman in the 1920s in the sleepy little town of Westerville, Ernest (Teddy) Tedrow was a fixture in the community as he made his rounds. Law enforcement was not something many residents thought about in that quiet era. Tedrow mainly checked doors uptown. Serving Westerville as a police officer for 20 years, Tedrow was a formidable presence, and many young pranksters of the community were stopped in their tracks when he appeared.

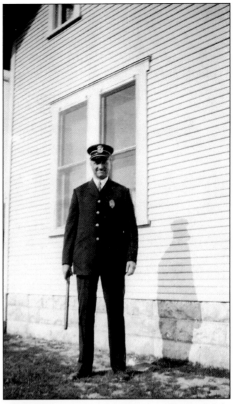

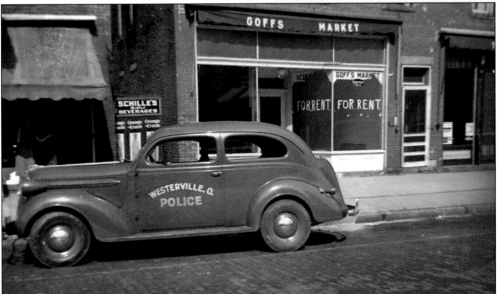

Officer Tedrow made his rounds on foot but as the town grew, a police car was added to the city fleet. One of the most daring crimes of the 1930s required more than a night watchman on foot carrying a night stick. December 18, 1930, two bank robbers held up the Bank of Westerville. Armed with pistols, they threatened employees and customers. The robbers netted $6,529 and fled. They eventually were captured and received long jail sentences.

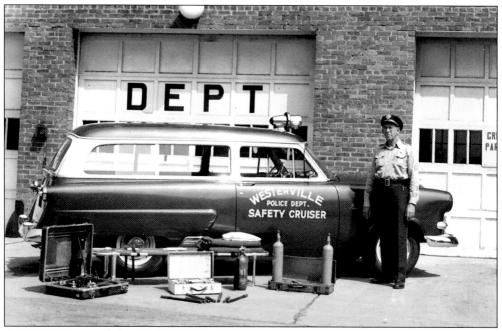

City services expanded to include emergency medical services. Sergeant Jeff Hall posed in the 1950s with equipment purchased by the city. This medical apparatus was used to provide life-saving transport capabilities to the safety cruiser.

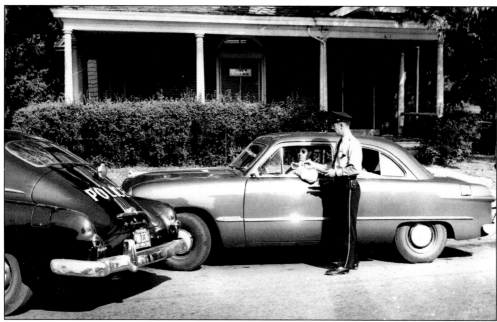

One of the first ordinances, passed after Westerville formed a government, prohibited driving at a "reckless, immoderate, or improper speed" and racing in the streets. Thinking only in terms of horses, the first council could not envision this traffic stop. Officer Dahlke, later the first police chief, issued a ticket to this motorist. The first full-time traffic officer was hired in 1924, and in 1925 of the 123 cases handled by the police department, 107 were traffic violations.

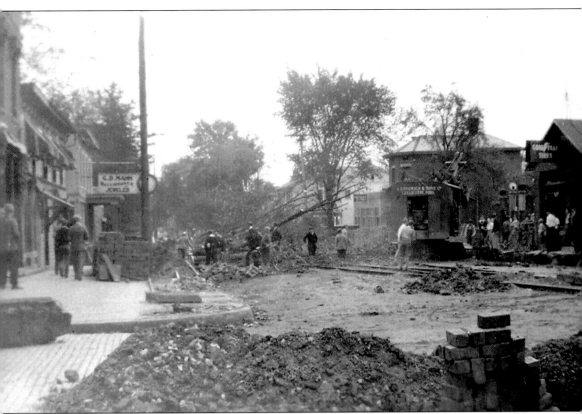

In 1929 the town undertook a street improvement project to widen and improve State Street. Property owners on State Street between Walnut Street and Home Street were required to help pay the bill with business owners paying more than home owners. This photo was of the work progressing south of College Avenue. The B.T. Davis home, later remodeled as the city building, is the large brick building in the background. A tree is being removed to aid in the construction. Residents were very vocal about protecting their trees when improvement work was initiated by the city. Some stood guard over beloved trees to prevent their removal.

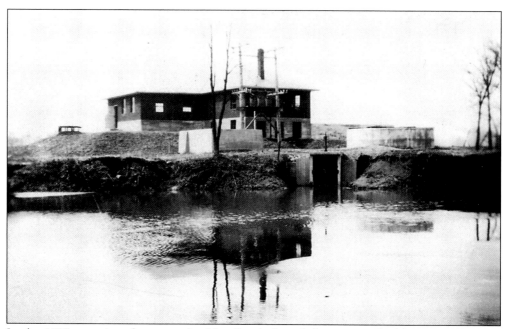

In the 1920s warnings from state health officials forced the town to build a water filtration plant. Located on the west bank of Alum Creek and pictured here, it was erected in 1924. Initially water was drawn from four wells in the vicinity. The last one in use was the one enclosed in the circular concrete wall in the right of the photo.

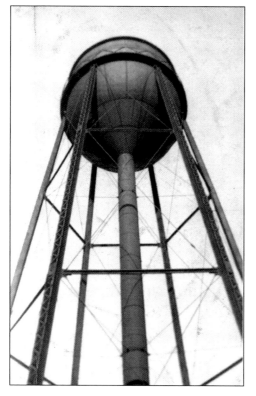

Built in 1920 on East Main Street, this water tower had a 200,000-gallon tank. The structure stood 130 feet off the ground. Built at a cost of $21,876, it took two months to build. The total weight of the steel in the tank was approximately 300,000 pounds. It was a very recognizable feature in the uptown district.

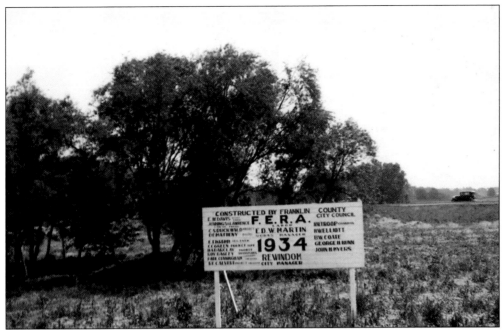

Westerville residents were the beneficiaries of numerous works projects during the Depression. The beginning of the current parks system began when federal government funds were used to develop the land along Alum Creek near the Main Street Bridge and turn it into a municipal park. This sign at the park location signals the beginning of the project to transform the undeveloped land.

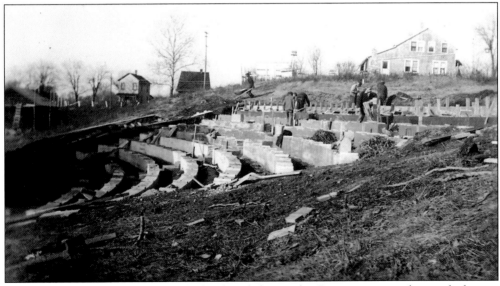

One feature of the municipal park developed during the Depression was the amphitheater. Workers are shown building the structure into the side of a hill on the east side of the park. Many concerts and special events were held at the amphitheater in the years after its completion and it continues in use today.

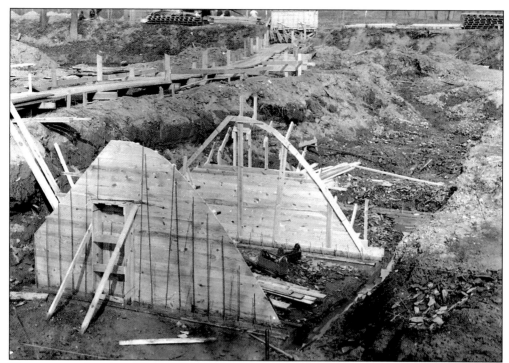

The municipal park was developed after the construction of a dam on Alum Creek. The building of the dam was one of the most important projects undertaken during this period. The flow of Alum Creek was controlled, and a dependable water source was developed. The dam cost $44,000 to construct.

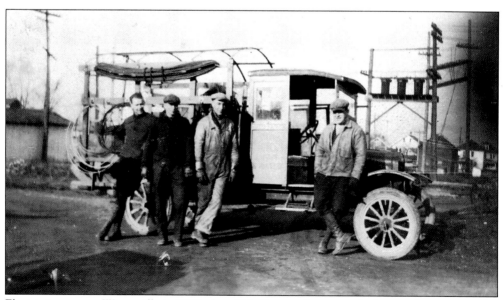

Electricity came to Westerville in 1898 when H.L. Bennett began producing it at his stump-puller factory. The town council took over the power business in 1907. This photo, taken before 1920, showed the city work crew with their truck. Popular city manager Ross Windom is on the far right in the photo.

Five

TRANSPORTATION

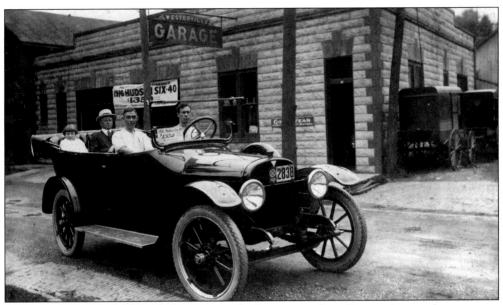

In 1806 Edward Phelps logged the expenses for his journey from Connecticut to the new state of Ohio. All but five of his entries were for items to prepare his wagons for the journey over the rough roads he had traversed the preceding year with Isaac Griswold. The Griswold-Phelps migration to Ohio was hindered by the narrowness of the Indian trail or "traces," which were the only avenues through the thick woods. The travelers had to hack away trees and undergrowth to make the trails wide enough for their wagons. With no bridges to cross them, streams and rivers presented obstacles. Gradually as time passed and more settlers came to the area, the Indian trails became mud roads wide enough for wagon and buggy travel.

In the 1850s enterprising citizens sought to remedy the mud road situation with the formation of the Clinton-Blendon Plank Road Company. Mud was scraped off the roadway. Logs were cut, planed, and laid on the road bed. The 8-mile stretch of plank road cost $2,000 a mile to construct. The company erected toll booths and began to charge each and every traveler over the log road. This commercial enterprise paid one dividend to its stockholders and soon became the victim of washouts and rotted logs. The toll road was sold to the Franklin County Commissioners, and Westerville residents were pleased to be able to travel to Columbus without paying the toll.

When the train and later the trolley came to Westerville, residents no longer had to rely on their own vehicle or the stagecoach to make the two hour journey to Columbus. These forms of modern transportation opened up the community as nothing else, until the advent of the automobile at the beginning of the 20th century. The town assessor counted 136 horses in 1901, and the Weibling livery stable was a leading business, but the age of the auto revolutionized Westerville along with the rest of the country.

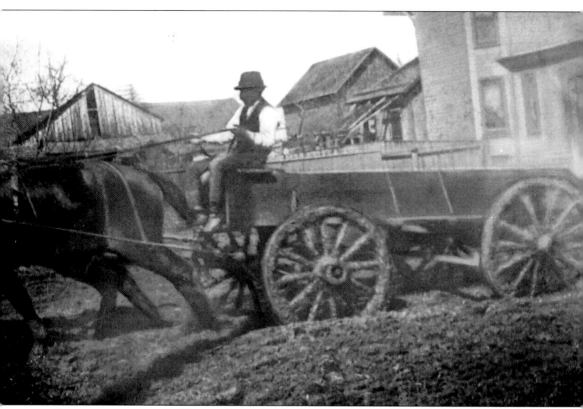

Transportation in early Westerville was a challenge. Stories abound of wagons stuck in the mud and inventive drivers taking their horses on the wooden sidewalks to avoid the muddy roads. Stagecoach passengers dared not lean their head out the window for a look at their surroundings. A face full of mud might be their reward as the horse's hoofs kicked up the ever-plentiful goo. Pedestrians were in grave danger of wearing a coat of mud if a passing conveyance came too close. The uptown area was on land that had been described as a swamp in early writings. By the early years of the 20th century Westerville's reputation for its muddy streets led citizens to take action. The editor of the *Public Opinion* described the condition of the streets as, "a sublime quality and quantity of mud." There was a lot at stake. Otterbein, disgusted at the lack of progress on issues like the muddy roads, considered moving the college. At the urging of citizens the council voted to issue a bond for paving the streets. A sigh of relief swept the community. This team and wagon was slogging through the mud on East College Avenue.

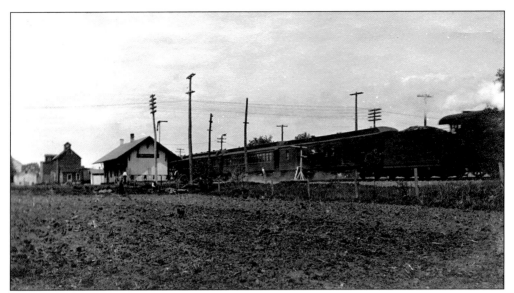

When news arrived in Westerville that the railroad was coming, but not through their community, enterprising businessmen went into action. They bought $20,000 worth of railroad bonds in an effort to sway the decision on the route. Their efforts were successful. The village celebrated when on September 1, 1873, the first train rolled into town. This train is near the Farmers Exchange and the railroad depot.

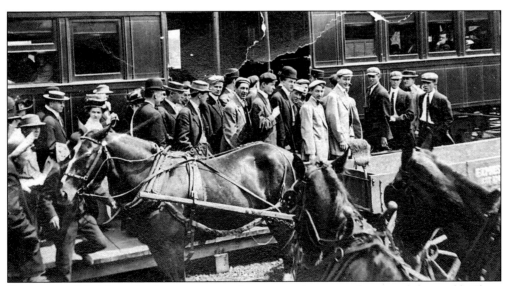

Passenger and freight trains began to open the community up to the rest of the world. These Otterbein students are gathered at the train depot in Westerville. The railroad continued to be an important part of the transportation cog in Westerville until after World War II, when passenger service began to taper off. In 1948 the railroad ceased offering passenger service through the town.

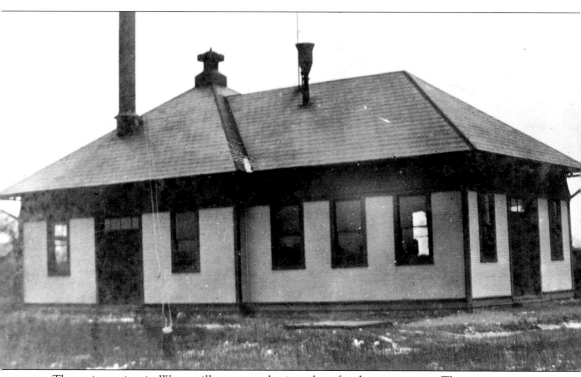

The train station in Westerville was a gathering place for the community. The curious citizens wanted to see who was arriving on the two passenger trains that stopped daily. A building boom occurred on the east side of State Street. The train made it possible for men to relocate their families to Westerville to live but to continue to work in Columbus. The commute by train was a better option than the trip by horseback. Many of the new residents were traveling salesmen who relied on the trains to take them from location to location. The boom years of the railroad in Westerville were those after the Anti-Saloon League located their printing headquarters in the community. The volume of printed material that had to be mailed and transported by rail made the League the most important customer of the railway line.

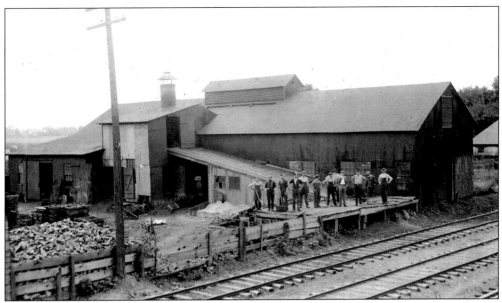

Businesses began to spring up near the railroad tracks. The opportunity to access the convenience of rail transport of goods produced in Westerville caused entrepreneurs to bring their manufacturing operations to the village. This fueled the housing boom as more workers moved to the village. This photo shows the close proximity to the railroad tracks of what was later part of Kilgore Manufacturing.

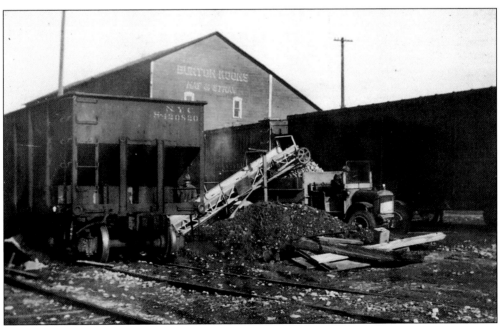

Equipment at Burton Koons Hay and Straw is prepared to load a railroad freight car on a siding. The rural areas surrounding Westerville took advantage of the railroad in Westerville by bringing crops to town to be weighed and shipped for distribution. The railroad was beneficial to all aspects of the local economy for many years. By the time Westerville became a city in 1961, the railroad's influence on the city's economy was considerably less than it had been in earlier years.

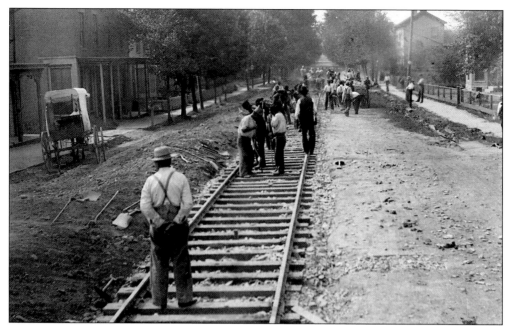

One of the most exciting events of the 1890s was the laying of the tracks up State Street for the electric streetcar/interurban line from Columbus. The arrival of this new form of transportation was the result of an incident involving Gerry Meeker. Families waiting for the south-bound train to take them to the Ohio State Fair were passed by an overcrowded train that did not even slow down. Meeker, surrounded by disappointed family members, vowed to bring a new form of transportation to town.

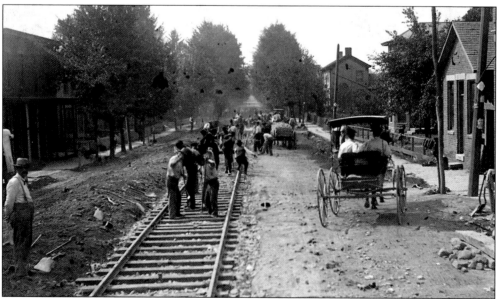

In 1892 Westerville citizens raised $35,000 in subscriptions and granted a franchise to the Columbus Railway Power and Light Company to promote the building of the trolley line to their community. The tracks came up State Street and ended at Old County Line Road. Buggies and wagons traveled side by side on the street with the trolley when the line was completed.

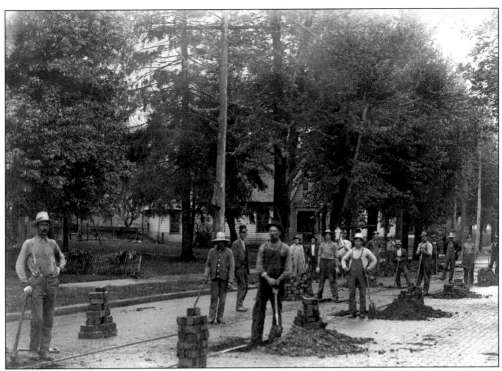

Upon completion of the trolley/interurban line, travel time to Columbus in the trolley car was one hour. The trolley ran from 5:24 a.m. until 11:00 p.m. with cars traveling the route every 45 minutes. The fare was 25¢ for a round trip to downtown Columbus. Families had a new option for traveling south.

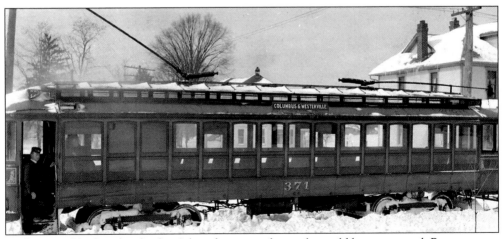

Trolley travel had its drawbacks. A lot of snow on the tracks could hamper travel. Because most of the land between Westerville and Columbus was rural, cattle would block the tracks and have to be herded off. Residents once again began to complain of overcrowding of the cars at peak travel times. Slow service also raised local tempers. The trolley cars were not always well maintained in the early years so broken windows made for a drafty ride.

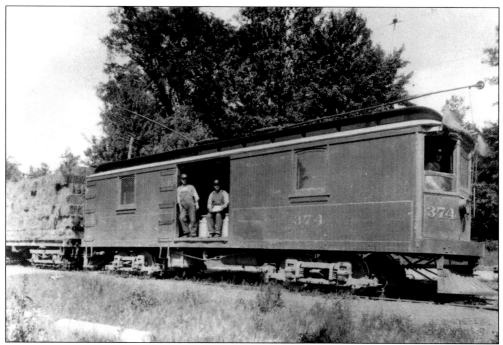

The trolley transported freight as well as passengers. Pictured from left to right are Bert Conkle, John Meeks (conductor), and Ernest Sage (motorman in the front window). This trolley was pulling a load of hay bales, and the interior of the car held milk containers. This cargo is representative of the agricultural products transported by the trolley from Westerville.

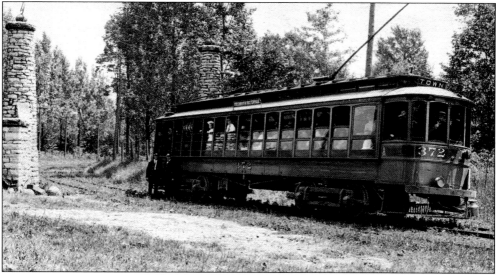

The trolley tracks ran through the entrance into Minerva Park south of Westerville. The park was built as an entertainment center with attractions for all ages. The intent was to increase trolley revenue as riders came from Columbus out to the park. Lakes were carved, grounds laid out, and a roller coaster built to attract the public. Other amenities included a large concert venue called a "casino," even though no gambling took place in the building.

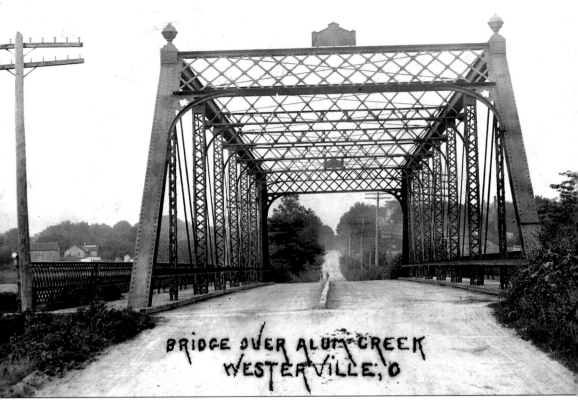

BRIDGE OVER ALUM CREEK
WESTERVILLE, O

Roads were laid out connecting Westerville to the surrounding communities and countryside. This iron bridge spanned Alum Creek on Main Street, aiding those traveling west. The view is looking west. In the early days of the community, passengers and their wagons were forced to ford Alum Creek at Park Street since the creek was shallow at that point. Further south, a basket was strung across Alum Creek on a rope and passengers were pulled across in this woven contraption. The distinctive iron Main Street Bridge was built in 1894 and served as a main east-west connector for 75 years until its replacement in 1969.

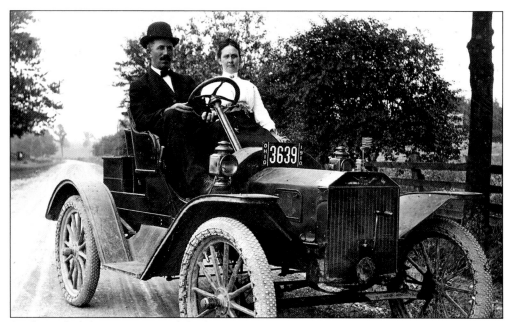

At the end of the 1890s automobiles began to appear on Westerville streets. One of the proud owners of the new-fangled machine was Frank Everal, pictured here. His open touring car sported a 1910 Ohio license. The muddy roads made automobile traffic difficult, but local citizens were enthralled, and gradually more and more of the vehicles appeared, and citizens began to be concerned with speed limits and road improvements.

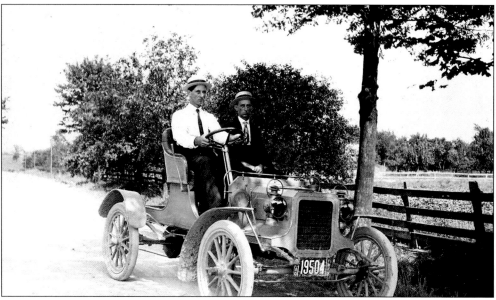

Two of the local citizens who were part of the trend to use automobile transportation are pictured here; Herbert Schrock (left) and, in the passenger seat, Clarrel Schrock. One local man even patented his own auto, the Sharf Gearless, and tried to market it to different Indiana auto factories. Only two of these autos were built, and there were no commercial sales. The first model had room for the driver only. Unfortunately John Sharf crashed his car into a telephone pole on State Street.

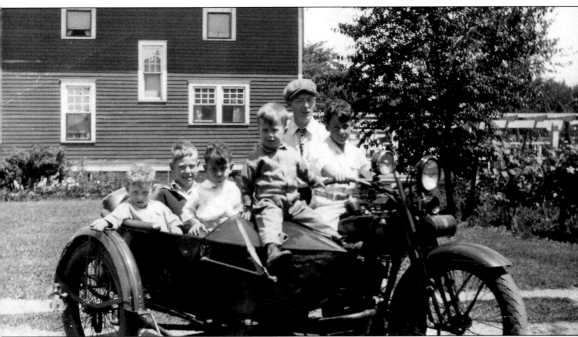

As Westerville citizens began to purchase their own automobiles and travel around town and in the countryside, the demand for the interurban and the passenger train service to Columbus diminished. The trolley service ceased in 1929. The day after the last trolley traveled up State Street, greyhound bus service began to carry passengers to and from the town. Most traces of the trolley were erased when the tracks were removed from State Street. The old trolley barn at the end of the route on Old County Line Road remains and for a time was used as a service station for automobiles. These youngsters enjoyed being transported in a 1926 Harley Davidson: Howard Rich, Jack Rhodes, Bobbie Curfman, Jack Lane, Ed Richardson, and Bud Curfman.

In 1941 looking east on Walnut Street from near State Street, the dirt road stretched into the distance through wooded areas without the hustle and bustle of the auto traffic of present-day Westerville. In the early days of the community some of the rural lanes, including this one, had different names. Walnut Street east of State Street was called Cheever Road, Hempstead was Hart Road, Moss Road was School-house Lane, and Cleveland Avenue was Harbor Road.

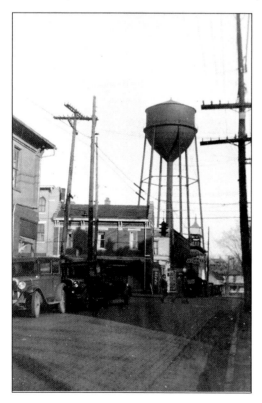

Westerville had parking problems even in the days of the horse and buggy. Early residents and those farmers who came into town on Saturdays to shop complained about not having enough hitching posts to tie up their wagons and horses. This photo, looking east on Main Street at State Street, features three autos parked bumper to hood on the north side of the street with no space to spare. The parking problems continued into the automobile era.

Six

BUSINESS AND INDUSTRY

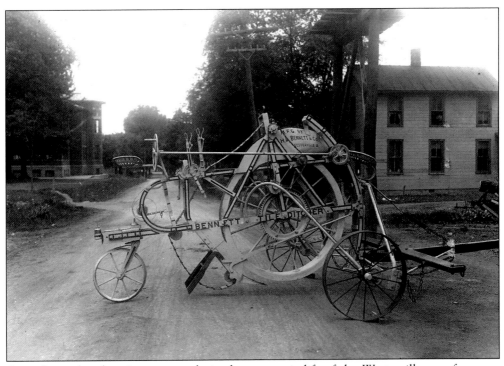

Agriculture played an important role in the economic life of the Westerville area for many years. However, even in the beginning the settlers sought to find endeavors other than farming to help sustain their families. On Edward Phelps' list of items to bring to his new home was "one great wheel for mill." Phelps built a mill on Big Run in 1807, obtaining most parts of the mill from the hickory, gum, and oak trees of the area. Others followed in his footsteps and built mills along the waterways of the Westerville area. These were the early businessmen of Westerville. As a new generation of citizens grew up in Westerville, different business opportunities began to present themselves. Thomas Alexander was a good example of this second generation entrepreneur. Having worked in one of the Westerville mills, he decided to open his own business, a foundry. Located on the corner of Main and Knox, the Alexander foundry was of note for several reasons: it provided the window weights for the new statehouse in Columbus; produced a windmill—the "Alexander Storm King"; and was a hiding place for fugitive slaves. Not content with being just a successful businessman, Alexander also was a founder of the Masonic Lodge in Westerville and was the community's mayor.

The 20th century brought a new crop of businessmen and manufacturers who hired local labor, were part of the social life of the community, and took on the mantle of civic and government leadership. Westerville prospered with their assistance.

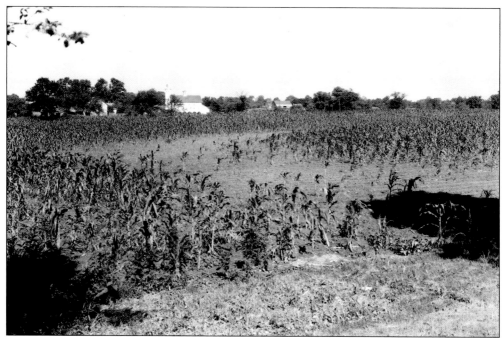

The Everal farm, established between Cleveland Avenue and Alum Creek, was one of the farms that dotted the landscape around Westerville. Agriculture was the primary driving force in the economy of the area for several generations after the first settlers arrived. Clearing the land to make it useable for growing crops was back-breaking work, but gradually fields were created. Corn stalks rising from the earth were a common sight to travelers through the area.

Barns and outbuildings for livestock and chickens were part of the Everal farm operation. Earlier agriculturists grew and raised everything to meet the needs of their families. Log books, meticulously kept by some early residents, bear testimony that the economy of the early years was primarily a barter system with little money changing hands.

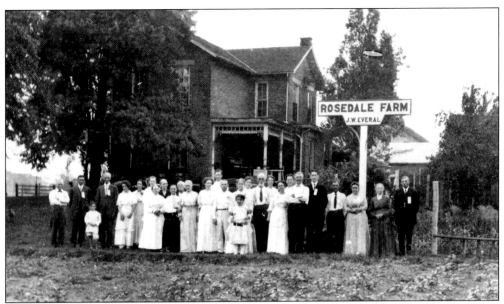

As time passed, farm operations became more sophisticated, and farmers like John Everal became more prosperous. Small log homes were replaced by two-story frame or brick farmhouses. Everal proudly posed in front of his brick farmhouse with family and friends in 1914. The purpose of the gathering was to christen his property with the name "Rosedale" in honor of Everal's beloved second wife Rose. John Everal was the man with the white beard in the center of the photo, and Rose is to his right.

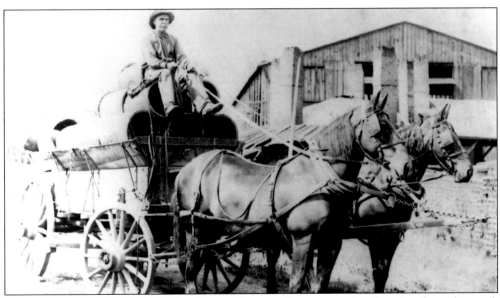

The Everal farm, west of Alum Creek, was the site of extensive clay deposits along the creek bank. In 1872 Everal started a tile factory that manufactured drainage tile and bricks. He is pictured here hauling a load of the drainage tile. By 1883 Everal's business was Westerville's largest manufacturing concern. The tile was popular as municipalities began to attempt to control the drainage in their communities through public works projects. The bricks were used to build many Westerville buildings.

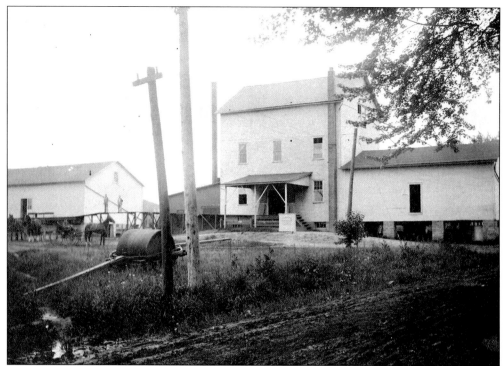

Many businesses were developed in Westerville to provide services for and deliver goods to farmers in the area. Frank Burrer opened this flour mill around 1900 near the railroad tracks. A newspaper article attributed the importance of the Burrer Flour Mill not just to the men it employed for its business, but, even more, to the farm trade it brought to town. This aided all the merchants, as farmers would purchase other goods while doing business at the mill.

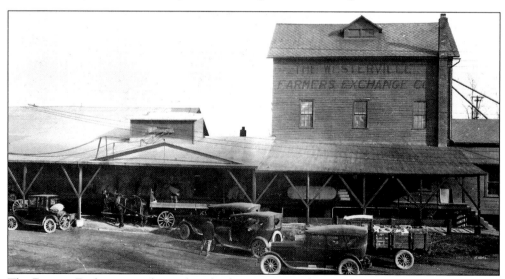

The Farmers Exchange was located in the former Burrer Flour Mill building. One hundred and thirty farmers bought it in a cooperative arrangement in 1920. It continued to handle milling but diversified to meet farmers' needs for coal and other products. The operation grew to encompass seven buildings and by 1930 was an up-to-date grain-handling warehouse.

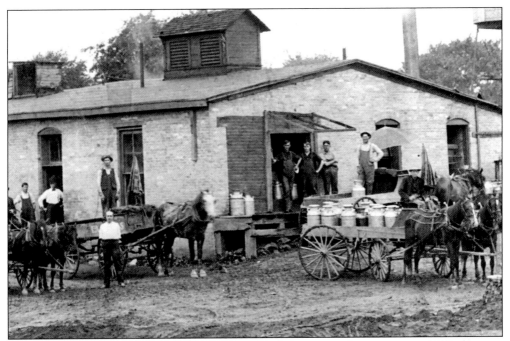

The Westerville Creamery was founded by W.B. Johnston and a partner in 1900. Farmers brought dairy products to the business in large metal containers. Once in the plant it was separated, with the cream being retained and the skimmed milk returned to the farmer. Initially the cream was then sold to processors who turned it into ice cream and margarine. The machinery used at the plant was considered very modern and included a pasteurizer.

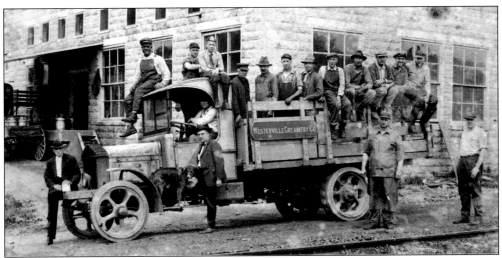

In 1926 the Westerville Creamery began to process milk and sell it wholesale and retail. A decade later they turned to processing evaporated canned milk. During World War II much of their production went to provide canned milk for the troops. The business became the largest family-owned evaporated milk plant in the United States. Eventually the business was sold to Borden, and ceased to operate in 1987. In this 1921 photo W.B. Johnston is the man petting the dog.

Harwell Bennett founded the Bennett Manufacturing Company in 1883. For 89 years and three generations it continued to operate in Westerville changing its product lines to meet changing demands. From 1883 until his death in 1917 Bennett was a risk-taker and one of the leading entrepreneurs of the community. He is pictured here in 1890.

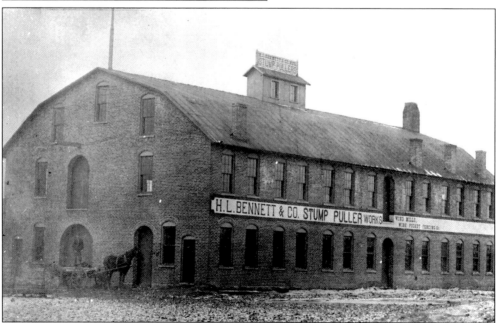

The Bennett factory on East Home Street was constructed in 1890 at a cost of $2,500. Locating near the railroad station and right-of-way simplified transportation of products. The business manufactured stump-pullers, wire picket fencing, farm wagons, tile ditching machines, corn harvesters, and lumber products. Bennett was also responsible for development of the first electric plant in Westerville.

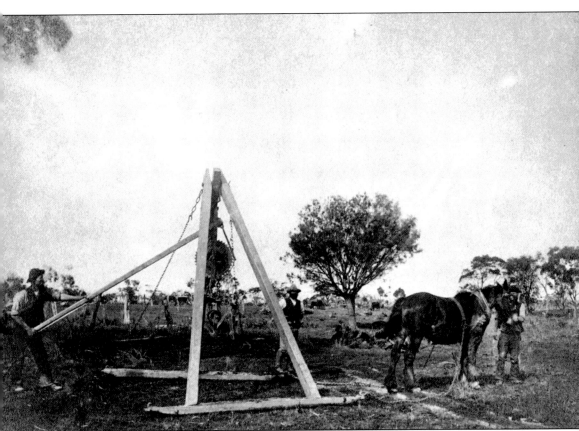

The Bennett stump-puller was instrumental in clearing stumps from the Ohio State Fair grounds and in clearing stumps from farmland in Russia. From 1883 when 68 stump-pullers were produced, to 1892 when 324 were shipped, it became an international business. Patented in 1874, the piece of equipment was sold by James Mossman for several years before he turned it over to his nephew Harwell Bennett. In 1884, Bennett had a unique opportunity to display the usefulness of his product. Harwell, his brother Russell, and a cousin, Biggy Adams, took the stump-puller and put it to work clearing the Ohio State Fair grounds. The men spent six days clearing 132 stumps. This worthwhile activity produced letters of endorsement that were used to sell the product far and wide. To further promote the product Bennett advertised in farm newspapers and took the stump-puller on the road to fairs where he exhibited its capabilities. In 1892 the stump-pullers were shipped to 31 states and 7 foreign countries, including Russia, Australia, and Germany. The product was used at a time when more and more land was being cleared for cultivation. By 1912 the demand for the product had disappeared. The resourceful company turned to making corn harvesters to take advantage of the demand for a product to be used on the newly cleared land. The corn harvester was in production for over 40 years, and at its peak superseded even the sales records of the stump-puller.

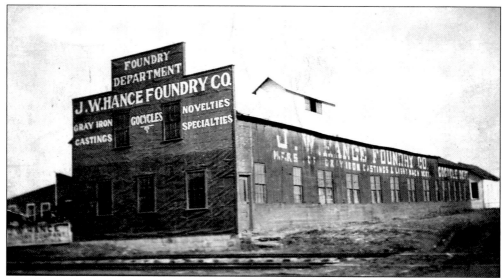

In 1907 the Hance family, J.W. and son Harry, moved their foundry business to Westerville from Plain City, Ohio. Harry Hance moved into the community, and the Hance family founded a local business that operated continuously for 93 years. The foundry building beside the railroad tracks was pictured here.

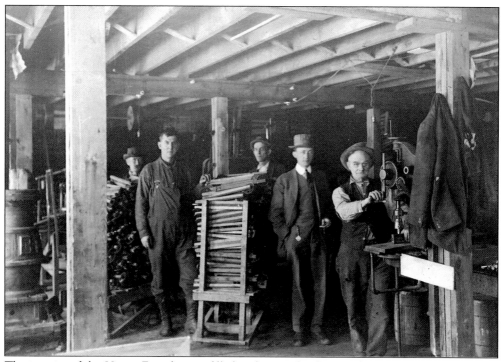

The interior of the Hance Foundry was filled with parts for the popular Go-cycle, stacked ready for assembly with workers finishing the manufacturing process. The foundry originally produced industrial castings, but eventually began to manufacture vending machines and promotional items. The vending machine business produced a variety of metal and glass containers, which dispensed everything from peanuts to stamps, with one even dispensing a lighter for cigar smokers.

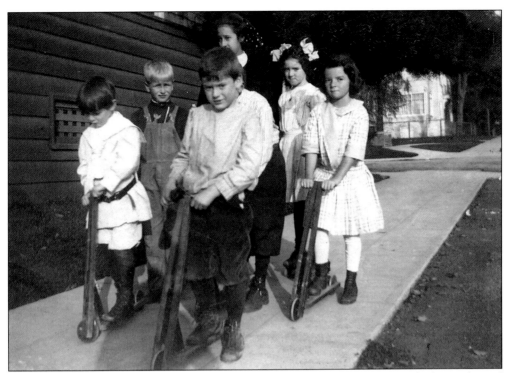

The Hance Go-cycle was popular across the country. This promotional photo showed youngsters in California playing with the toys. The wooden two-wheeled scooters were generally used by banks and other business concerns as promotional items and give-aways to lure customers to their businesses. Some of the scooters came with runners like ice-skates for use in the winter on snow and ice.

Hance Manufacturing turned to producing seed-cleaning machines and products for farmers. This photo showed the Hance display of seed-cleaning machinery at the 1939 Ohio State Fair. Interested customers were looking at a demonstration of the machine. Hance Manufacturing was another example of a local business that adapted as times changed. In the 1960s it turned to making conveyors to move farm products and bins for storage.

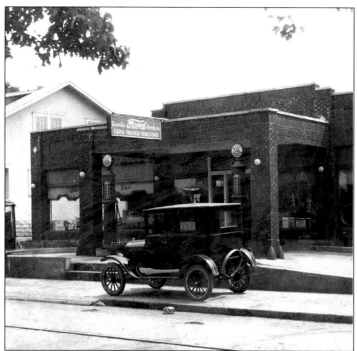

This is a 1924 view of the Ford dealership in Westerville on South State Street. Once the auto was introduced into the community new businesses sprang up around town to take advantage of the population's eagerness to embrace progress. Farm tractors were prominently displayed in the showroom—evidence of the strong farm influence still felt in the local economy at this point in time.

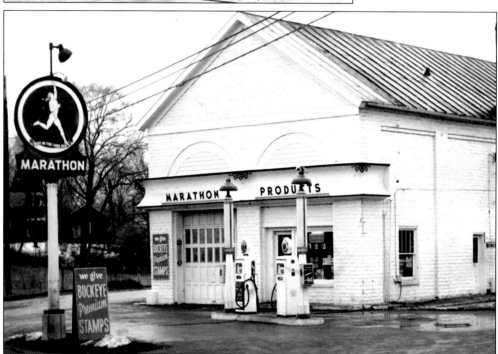

The former trolley car barn located at the end of the route at Old County Line Road and State Street was converted when the auto became the popular mode of transportation. Gas stations popped up on the outskirts of the community, as well as uptown, to support auto travel. Auto repair businesses also appeared in town as citizens unfortunately discovered the need for service and repairs on their cars which they could not always provide themselves.

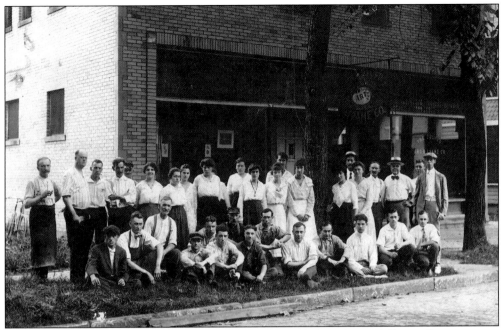

Founded in 1900 in Westerville by Frank Culver, the Culver Art and Frame Company was another company with international customers. By the 1920s Culver Art and Frame was offering a wide range of products, including frames, convex glass, pictures, mirrors, tables, and framing supplies, which they shipped all over the world. Several devastating fires in the 1930s almost destroyed the company. Percy Lehman, a longtime employee, purchased the company in 1941, and it continues as a family business today.

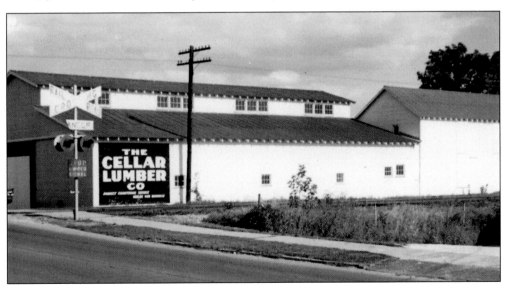

The Cellar Lumber Company is one of the oldest continuously operating Westerville companies in existence today. In October 1908 a group of men opened a lumber yard with less than $10,000 capital. Wilson Cellar was the secretary-treasurer and the only one of the founders who received a paycheck. He made $75 a month, and the only other employee, a teamster, made $12 a week. By the late 1950s, the company employed 75 employees at 8 lumber yards.

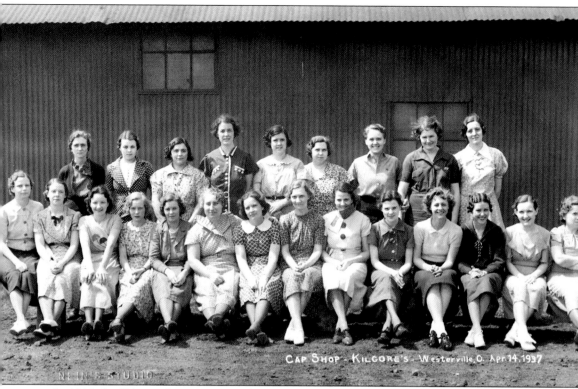

CAP SHOP - KILGORE'S - Westerville, O. Apr. 14, 1937

In 1919 the Kilgore Company moved its operations to Westerville. J.D. Kilgore brought the company to Westerville. Starting small, with just 30 employees, it became one of the most important employers in the community over the next four decades. The company manufactured flares, toys, plastic housewares, and, during World War II, munitions. By 1956 the company employed over 650 employees. A farm on Tussic Road was purchased before the war and housed part of the production. Incorporated in 1917 in Columbus, the company's primary business in the early years was manufacturing cap pistols and caps. By the 1950s, during the cowboy television craze, Kilgore manufactured a dozen different types of cap pistols and four different types of caps. By 1955 annual business was in excess of $5 million. The flare division was created in 1929 and began to supply the military with its products. Women were an important part of the work force, especially during the World War II years. The staff was close-knit, possibly because of the shared danger of working with gunpowder that could ignite with any spark.

Seven

UPTOWN

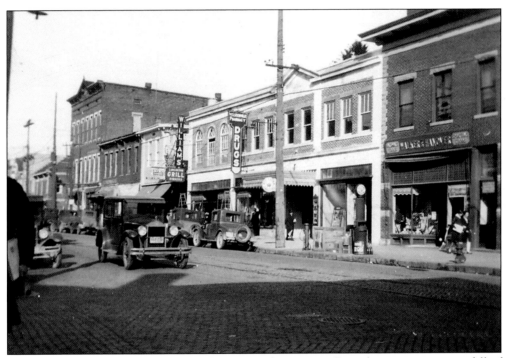

The uptown district of Westerville had primitive beginnings. Describing it as a swamp full of mosquitoes and frogs, one early resident said, "to ward off malaria a tall bottle of quinine stood on every dining table." Main Street was impassable, so Park Street was used as the east to west thoroughfare. In the midst of this seemingly dismal landscape, a village center began to develop. Jotham Clark opened a tavern in 1836 and J.B. Connelly opened a general store in 1838. In 1839 Mathew Westervelt and R.R. Arnold platted town lots, and the village of Westerville emerged.

With the coming of Otterbein, the business district was spurred to serve the needs of the students and a growing community. Amenities began to appear in the uptown district: stepping stones at street intersections, wooden sidewalks, and a town pump for refreshment. The town even had a town dog, Talus Newcomb, who went from business to house living on a diet of proffered scraps.

When frame structures were replaced by brick businesses, and the mud street was paved with bricks, the uptown district began to look as it still does today. Until the development of the first shopping center outside the uptown district, the businesses in the uptown district served all of the needs of the community. As transportation improved citizens might go to Columbus on a shopping expedition, but it was possible to purchase all the necessities of life in their own uptown area. Grocery stores, drugstores, dry goods stores, variety stores, millinery shops, and hardware stores met residents' needs.

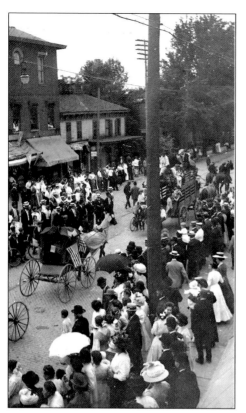

The uptown business district along State Street and some adjoining side streets has been the heart of the community since the Westervelts built a log building at the corner of Main and State Street. Celebrations took place, spontaneous or planned, with State Street as the hub. Citizens lined the street just south of State Street and College Avenue to watch a line of horse-drawn vehicles, decorated in patriotic red, white, and blue, parade down the street.

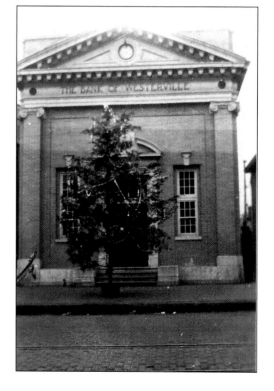

Uptown has been the scene of some less than pleasant events. One of the most daring crimes of the 1930s in Westerville occurred on December 18, 1930, when two bank robbers held up the Bank of Westerville. Armed with pistols they threatened bank employees and customers. All were forced to lie on the floor while the thieves collected cash from the establishment. They fled with $6,529. Eventually they were both apprehended and sentenced to lengthy prison terms.

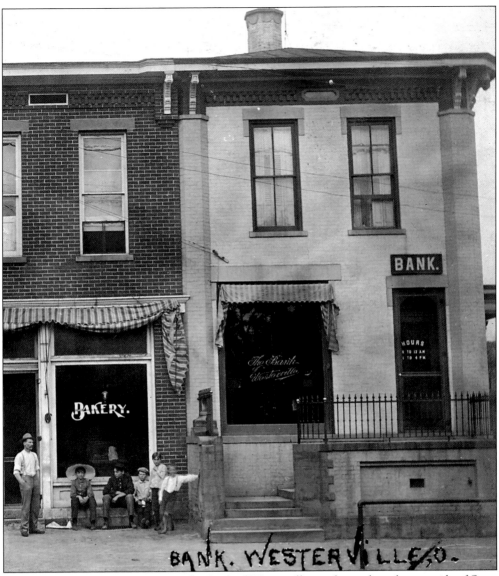

BANK. WESTERVILLE, O.

In this building from 1883 to 1913 the Bank of Westerville was located on the east side of State Street, eventually moving just across the street. Established in 1883 with eight depositors and first day deposits of $2,297.81, it was the first Westerville bank to fail during the Depression. A notice on the door of the bank on November 25, 1931, informed its 2,320 depositors that its doors were closed. This was one of the darkest days in the history of the community. Businessmen quickly leaped into action, pooled funds, and placed them in the hands of the trusted Wilbur Jaycox, a former teller with the failed bank. This stopgap bank was named the Iron Bank. Meanwhile through those dark days of the winter of 1931–32, businessmen and citizens worked toward the establishment of a new banking institution in the town. The goal was to have $25,000 to begin the new business and to obtain it through selling shares of stock for $120. The local merchants feared an outside bank coming in and wanted to ensure that a homegrown institution filled the banking vacuum left by the failure. Frank Bookman was elected president of the new Citizen's Bank at a stockholders meeting. With confidence restored, 210 citizens deposited over $40,000 when the new bank opened its doors in April of 1932.

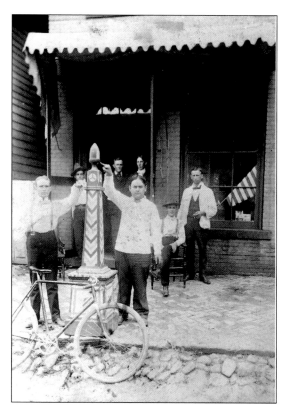

This barbershop was located on State Street. Customers posed alongside the white-coated barbers. The novel-looking barber pole was the point of interest. Barbershops were a part of the business community in uptown through the entire 20th century. Also of special note in the photo are the brick sidewalk and the mud road. The bicycle leaning against the pole was a popular form of transportation in the 1890s and early years of the 20th century.

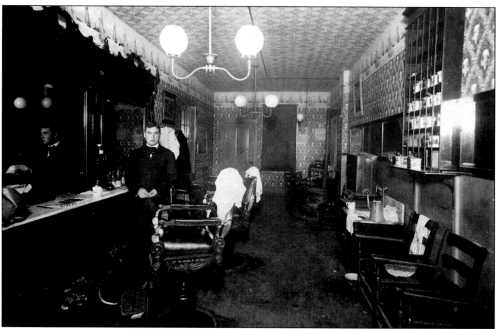

Barbershops were popular gathering places for male residents as they gossiped around the pot-bellied stove in the rear of the shop or were shaved using their own mug from the large case in the front of the shop. Levi Stump, pictured here, served his Westerville clientele for many years.

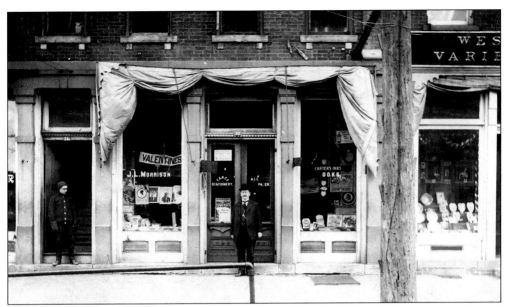

Located between the billiard parlor and the Westerville Variety, J.L. Morrison's business, University Bookstore, catered to the paper and book needs of townspeople and Otterbein students. A Civil War veteran, Morrison was an active part of the uptown business community, a valued member of the Grand Army of the Republic, and a published poet. Morrison started his business at the age of 60 and continued to serve citizens at his establishment for the next 20 years.

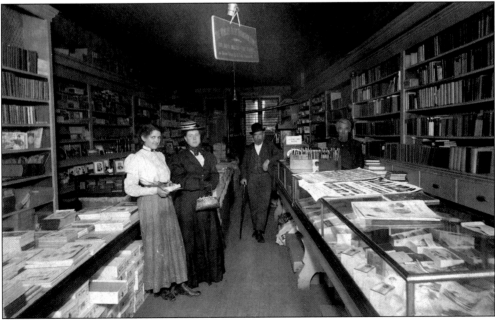

The interior of the University Bookstore was typical of retail establishments in Westerville in the early years of the 20th century. Packed with merchandise, heated with a pot-bellied stove in the rear of the business, and devoid of fancy eye-catching displays, this was what the shopper in uptown Westerville encountered. Most stores had few choices for consumers, but they received excellent service from the owner serving behind the counter.

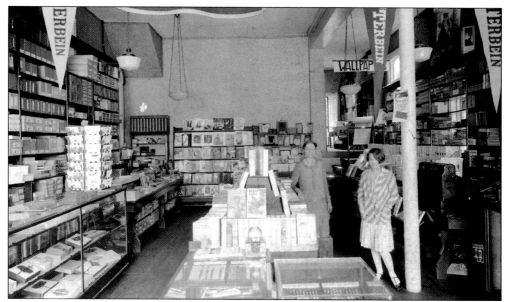

On the right in this photo Ellen Jones, granddaughter of J.L. Morrison, posed in a brighter, more expansive University Bookstore. More attractive methods of displaying retail goods in the uptown shops were part of a trend in the 1920s and 1930s. Otterbein banners hanging from the ceiling showed the allegiance of Miss Jones who valued Otterbein students as employees as well as customers. Many uptown merchants employed Otterbein students on a part-time basis.

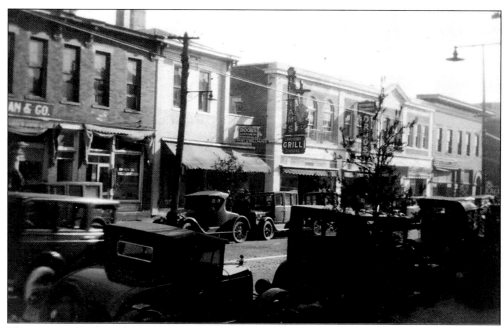

This was another busy day uptown as cars traveled up and down State Street in the 1930s. Not only did residents do their shopping in uptown some also made their homes above the businesses on the first floors of the buildings. Apartments with separate entrances were above many of the local retail establishments. One long-time uptown resident stated that when the weather was bad her five children roller-skated up and down the hall in their apartment over the local drugstore.

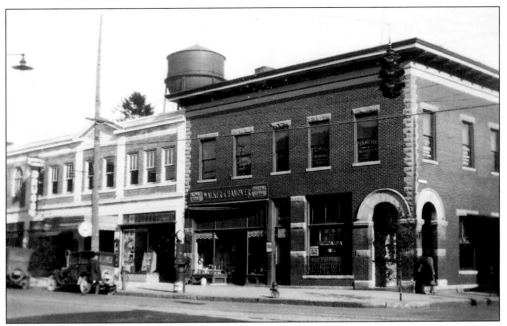

One sign of progress in a small town is when the business district has enough traffic to warrant a traffic light. Taken at the corner of State Street and College Avenue around 1927, this photo showed the traffic light used to control the flow of traffic on State Street. State Street was part of the major north-south route known as the 3-C Highway, linking Columbus and Cleveland.

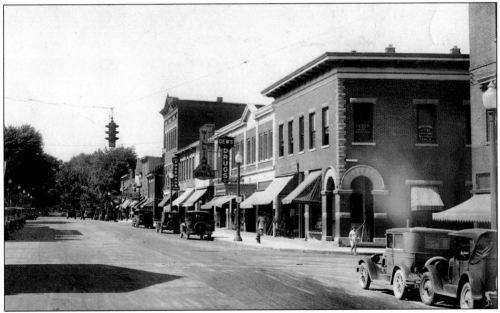

Looking north from State Street and College Avenue, this view shows some popular uptown businesses of the 1930s—Dew's Drugs, Williams Grill, and Freeman's. Dew's Drugs had a soda fountain, which was popular with the high school crowd. The electrical poles and wires evident in earlier photos were buried underground. Another sign of progress was the disappearance of the trolley tracks in the roadway of State Street.

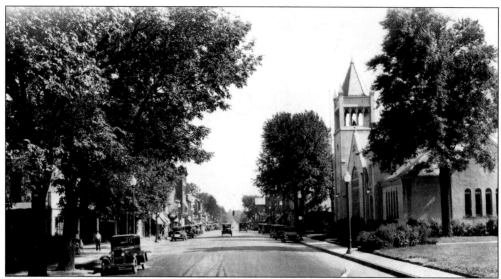

Taken from the northern edge of the business district, this photo showed "the quiet, peaceful village" in transition. The one traffic light is in the distance slowing traffic as it bustles through the town. To the south in the distance a heavily treed vista met the eye. The Methodist Church (Church of the Messiah today), on the right, occupied the building in this photo in the 1930s.

New streetlights illuminated State Street. A modern uptown area with brightly lit business signs was a contrast to the early days when Bennie Thurston lit the streetlights individually. Hired in 1872 when the first gas lights appeared in the uptown district, Thurston took his horse-drawn cart thru the uptown district cleaning the gas lights, lighting, and then extinguishing them. Considered one of the more interesting uptown "characters," Thurston had a following of young children who listened to his stories as he went about his rounds.

West College Avenue was the location of the original J.R. Williams ice cream business. His fancy, foaming ice cream soda sign signaled to customers that ice cream products were his specialty.

The business begun by Williams was run by three generations of the family before being sold in the 1960s. Eventually located on State Street, it became a booming business during the years after the 3-C Highway was paved, and travelers were looking for a good place for a meal as they passed through town.

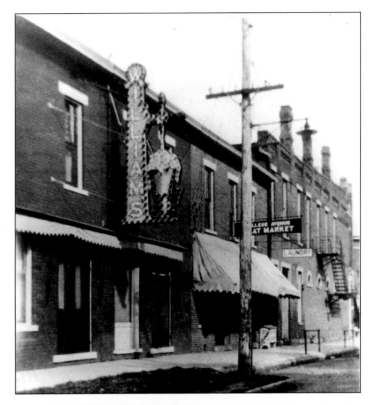

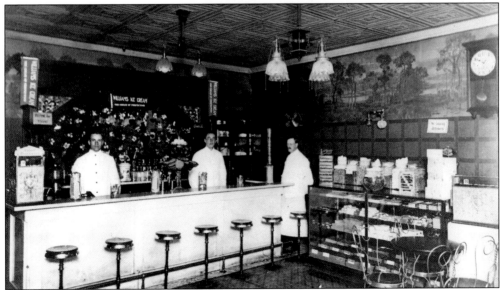

J.R. Williams, pictured on the right in the interior of his business on West College Avenue, opened his ice cream parlor in 1878 after friends and neighbors clamored for more of his homemade ice cream. His first sweet treats were produced when he cut ice from the frozen Alum Creek and used his own recipe to make ice cream. As time passed his menu became more extensive, and when he moved to State Street his business became known as Williams Grill, as he served hot lunches and dinners to his customers.

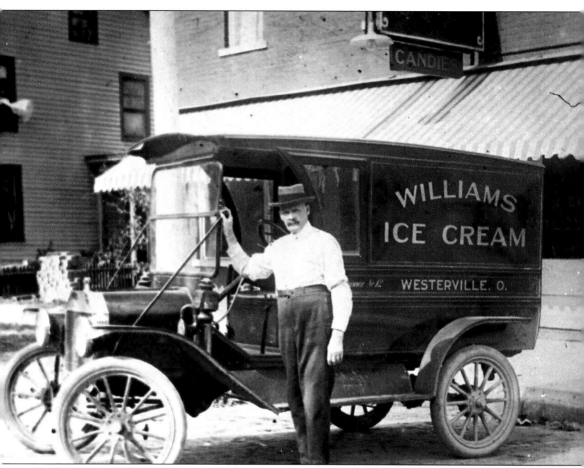

Eventually Williams Grill became one of the most noted establishments in uptown Westerville. Because of the quality of the service and food, its reputation spread beyond Westerville, and visitors arrived from around the state to eat at the restaurant. The motto on ads of the 1950s was "Where Friends and Neighbors Meet to Eat." At lunch time prominent members of the business community would gather for lunch. Civic groups and businesses used the Crystal Room on the second floor for dinner meetings. Wedding receptions were held in this room also. The first floor had a soda fountain with seating along its length. A menu from the 1930s advertises "Williams Grill Famous Sunday Dinners" for 80¢, 90¢, and $1; weekday luncheons for 40¢ and 50¢; Co-Ed Special 20¢ for chocolate and vanilla ice creams, butterscotch sauce, toasted cashews, and whipped cream; and a banana split for 15¢. The Grill had its own ice cream plant on premises, where ice cream was made with the freshest of fruit and other ingredients. Always striving for perfection the Williams family even roasted their own nuts on the premises. The business employed many high school students and Otterbein students to help serve. Because the ice cream was so popular, it was packaged for sale outside the restaurant. In this photo J.R. Williams posed beside his ice cream truck outside the State Street business. Like many of his fellow uptown merchants Williams delivered to residents' homes.

The uptown district was the locale that many civic organizations chose for their meetings. The second floor of this building, formerly on the southwest corner of College and State Street was used by the fraternal order of the Odd Fellows as a meeting site. The Rainbow Lodge of Odd Fellows was granted into charter on May 14, 1857, and initially held meetings in the schoolhouse south of Westerville. In 1860 it moved into the second floor of this building.

Throughout Westerville's history uptown has served as a gathering place for informal groups of men. Exchanging stories and news they would meet in the back rooms of businesses or in restaurants. The "Old Gang" gathered in 1924 at the Jaycox business at 39 North State Street. Pictured from left to right are Jeeter Taylor, Don Cubbage, James Swingle, Reed Rhodes, Abb Clapham, and Hoot Sanford.

Built in 1881, the Weyant Block is an impressive three-story brick building that anchors one of the key corners in the uptown district. It has housed grocery stores, variety stores, the telephone company, meetings of the Phythians, and a third floor theatre. One of the most tragic fires in the uptown district occurred in 1886 on the third floor during a play performance. An accident with a lantern lighting the stage resulted in a fire. Property damage was minimal, but three people lost their lives in the fire.

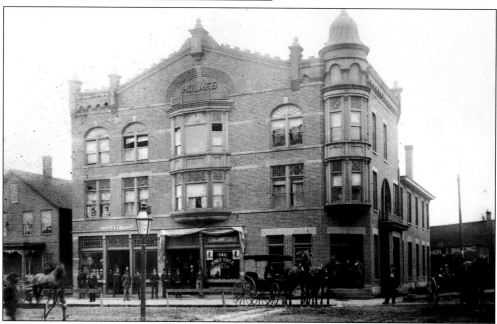

Another anchor building in the uptown district is the Holmes Hotel, built in 1890 by Thomas Holmes. The brick hotel had 30 guest rooms and included space for two retail businesses facing State Street on the first floor. In the rear of the structure a barn and livery stable served the needs of guests and citizens of the community. Formally opened with a dinner held by the Westerville Board of Trade, it was considered the finest structure in the uptown area.

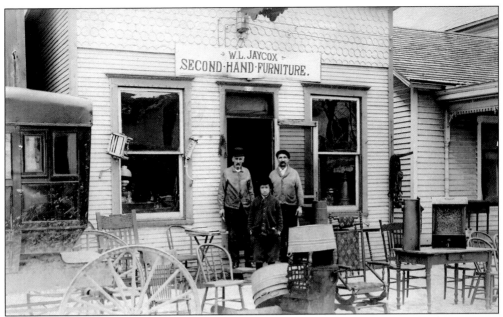

W.L. Jaycox owned a second-hand store on North State Street. A forerunner of today's antique shops, the business had an eclectic inventory of goods, and Jaycox displayed it on the sidewalk. W.L. Jaycox, on the left in the photo, could provide his customers with everything from laundry supplies (the stacked washtubs) to transportation needs (the harnesses hanging on the building).

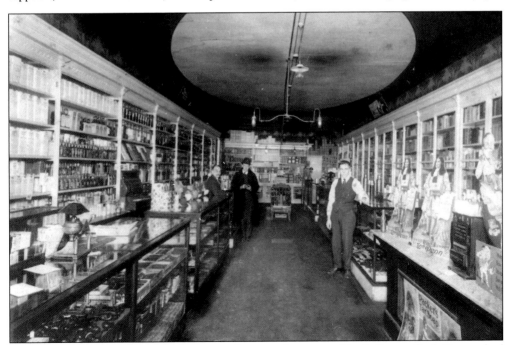

The uptown district was home to businesses that served every need including medical. Doctors had their offices in their homes in the heart of the community. Drugstores like Huffman's, pictured here, served the medicinal needs of the local populace. This building, on the southeast corner of State Street and College Avenue, was used as a drugstore for many years after it was built in 1878.

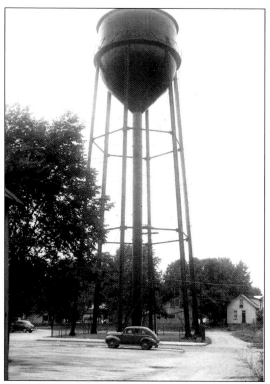

The Westerville water tower was another uptown landmark. Located on East Main it towered above the local landscape. Given a photo of Westerville it was easy to become oriented by finding the tank poised on its iron legs above the town. This photo taken in 1944 provides perspective on the size of the tower with the automobile at its base.

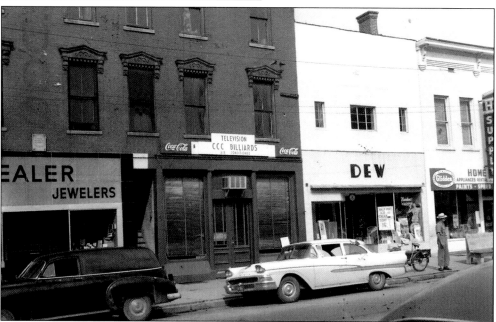

Entertainment in uptown Westerville included a billiards parlor when this photo was taken. Through the years residents could find something to fulfill their entertainment needs in the uptown district. They could bowl, skate, listen to music, attend plays, watch boxing matches, and attend the movies. One of the merchants in uptown also provided one of the first glimpses of the television, when he placed several in his store window for shoppers to view.

The town hall on East Main Street served as the first movie theatre in the uptown district, which cost 15¢ for admission. The State Theatre, pictured here, was opened in 1927 with a contest featuring a $10 prize, enticing entrants to name the new business. The theatre on State Street and its marquee attracted many Westerville moviegoers through the years.

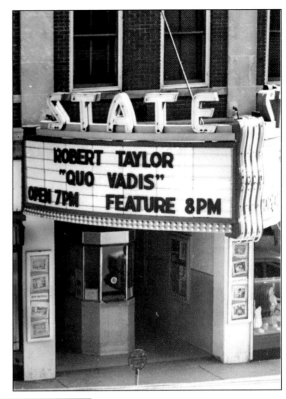

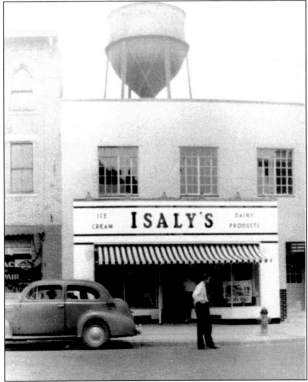

Most businesses in the early days were owned by businessmen who lived in the community, saw a need, and moved to fill it with their own establishments. Isaly's, with a building at the northeast corner of State Street and Main Street, was an exception. It was part of a chain of ice cream parlors located all over Ohio and in parts of Pennsylvania.

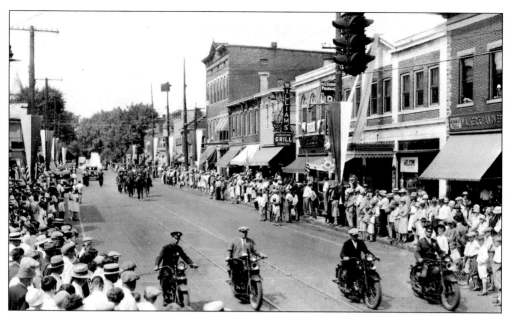

Westerville, close to the center of the state, was a good location for the 3-C Highway celebration and parade in 1924. The uptown district, anchored by the well-traveled 3-C Highway, hosted the event. Completion of paving of the part of the road linking Cleveland and Columbus was the reason for the celebration. The day-long festivities were advertised to communities along the route and drew large crowds.

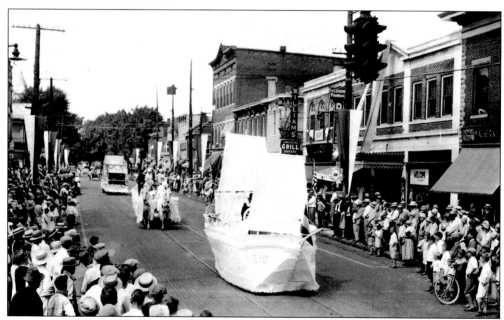

Invitations to communities from Cleveland to Columbus brought floats and thousands of visitors to Westerville for the one-day celebration. All 88 counties of Ohio, except one, had representatives in attendance. Everything from a baby contest with 40 entries to plane rides for attendees delighted those attending the celebration. The parade was the culmination of the town's efforts to make an impression on the visitors.

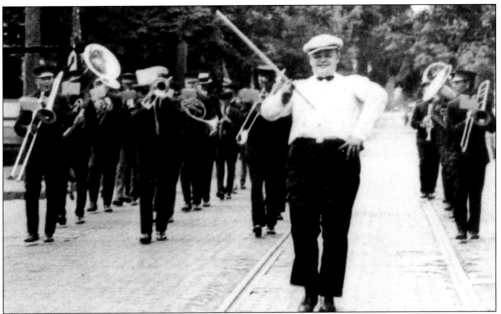

One of the highlights of the 3-C parade was captured in this photo. The Westerville Community Band was marching up State Street when Tubby Essington, Ohio State University drum major, felt moved to jump from his spot in the audience along the parade route, grab a broomstick from an uptown store display, and leap to the front of the band. Much to the delight of citizens along the parade route, he cut an impressive figure with hand on hip and broomstick waving to the beat.

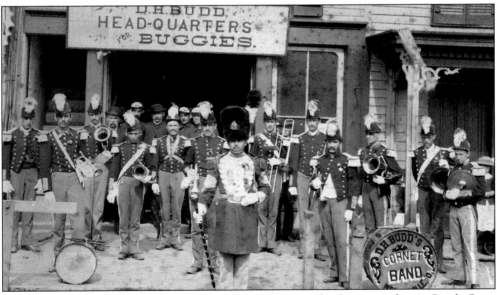

D.H. Budd came to Westerville in the 1880s and opened a buggy works on South State Street. He went into the country to retrieve broken wagons and buggies, brought them into town to his "buggy hospital" for repair, and resold them. His motto in early newspaper ads was "We are dealing." Part of his contribution to his adopted town was his support of this musical group—the D.H. Budd Cornet Band. They posed in their elaborate military-style uniforms in front of his business before one of their parades.

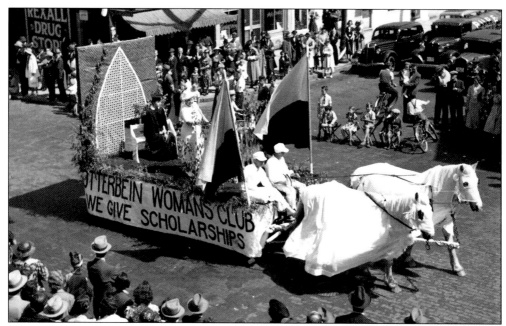

As the community recovered from the Depression a celebration was organized for the 150th anniversary of the formation of the Northwest Territory. Held in May 1938, one of the most important elements of the celebration was the pioneer and progress parade. The horse-drawn float shown here showcased the Otterbein Women's Club and their mission.

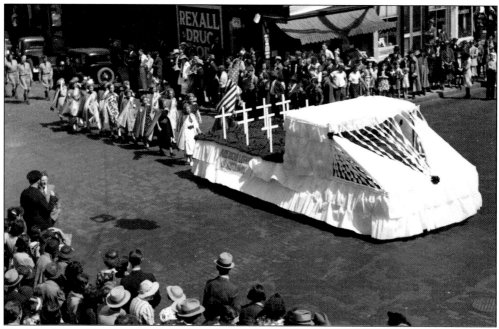

The Northwest Territory parade had 20 floats. The American Legion float honoring the World War I casualties moved past the Rexall Drugstore at the corner of College and State. Twelve members of the Westervelt family marched in the parade as part of the emphasis on pioneer heritage. A band concert, "pioneer" dinner, and pageant rounded out the day's events.

Eight

LIFE IN WESTERVILLE

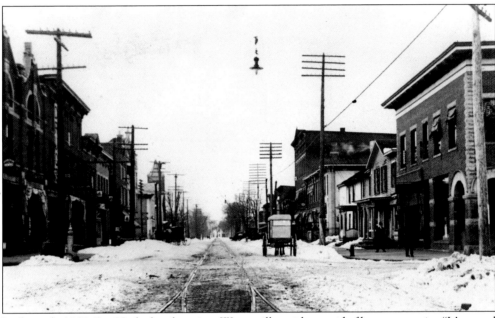

In the early 1960s Zoe Horlocker, longtime Westerville resident, said of her community, "It's a good place to come home to at night, after a week's vacation, longer sojourns or even years in other parts of the country." Westerville offered its residents a family-oriented, "dry" community.

Westerville residents liked their "quiet, peaceful village" to remain free of challenges to the moral fabric of their lives. Residents railed against alcohol, dancing, Sunday movies, and pool hall hours in the local newspaper. In 1903 the prospect of a dance in the town hall led to outrage until it was moved to a hotel. According to their moral compass, citizens helped runaway slaves before the Civil War, protested lynchings in other communities, and kept the sale of alcohol out of their town.

Lucinda Merriss Cornell came to the village in 1864 as a bride and chronicled 19th century everyday life in Westerville with her daily writings. She was a housewife and mother who raised six children to adulthood after becoming a widow. She worked from morning until bedtime to clothe and feed her family. She reflected the things that residents held dear—family life, education for her children, and civic pride. Life was not always easy for Lucinda—she lost a husband and children—but she diligently worked to make life better for herself and her family.

Westerville residents lived through times of joy and times of difficulty. They formed organizations to make their community a better place to live. They formed organizations to provide opportunities for social interaction. Programs were developed for the youth of the community. Celebrations were held to bring the citizens together. Zoe Horlocker also stated, "The United States is the greatest country on earth. Ohio is the best state and Westerville is right in the middle."

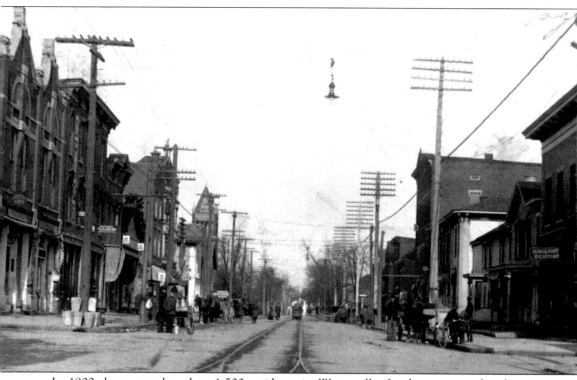

In 1900 there were less than 1,500 residents in Westerville. In the previous decade more elaborate brick buildings had begun to grace the uptown streets and communication and transportation began to broaden the horizons of local residents. However, Westerville was still a sleepy little community. Life was at a slow pace, with most townspeople acquainted with each other. Social life revolved around family, church, and school. This photo from around 1910 exemplifies this simpler life style.

By 1925 Westerville had blossomed. Residents took pride in the dry movement, which used their community as a springboard to bring prohibition to the country. The 3-C Highway began to bring more traffic through the community. Travel into the state capitol was easier because of this thoroughfare. This prompted travelers to use the highway to reach Ohio State football games and other events in Columbus. Businesses benefited because of this increased traffic. It also prompted Westerville residents to look further afield for shopping and entertainment opportunities.

As the decades of the 20th century passed certain trends changed life in Westerville. More and more residents took advantage of improved transportation to work outside the town and commute back into the town to live. Industrial concerns began to disappear. As they closed their doors the local economy became more service oriented. Because the population was growing and residents did not spend their entire day in the community, some of the small town characteristics began to disappear.

Home and family have been important to generations of Westerville residents. This brick home on Plum Street is a fine example of a family home built in the 1850s and still in use. The federalist structure was built by George Stoner, who owned the inn around the corner and was the stagecoach driver to Westerville. The area where the home is located was named Stoner District after the businessman. The grounds are of special note with their extensive plantings.

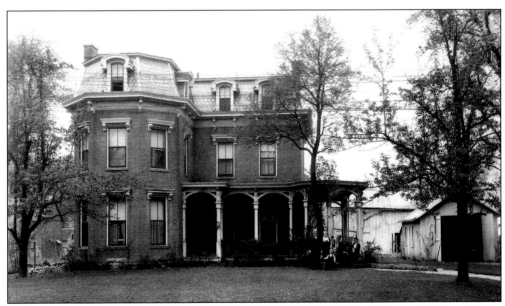

As Westerville moved into the later years of the 19th century, more elaborate dwellings began to appear on the tree-lined streets of the community. This home was on West Main Street and had three floors, a tower on the left side, and a wrap-around front and side porch. This 1921 photo shows the R.O. Cook family posing proudly in front of their impressive home. Later it was used by Otterbein College's Kings Fraternity.

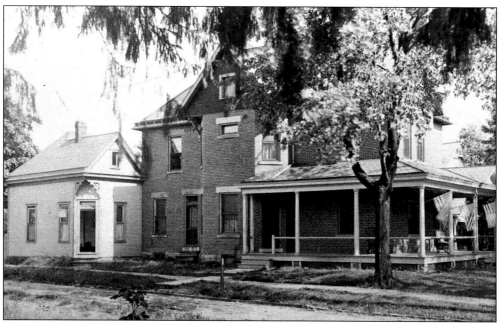

The Andrus property on South State Street was another example of a fine brick home. Just south of Winter Street, the property served a dual purpose. The owner Dr. Frank Andrus practiced medicine in the community and had his office as part of his family home. The structure was torn down as the uptown business district expanded southward.

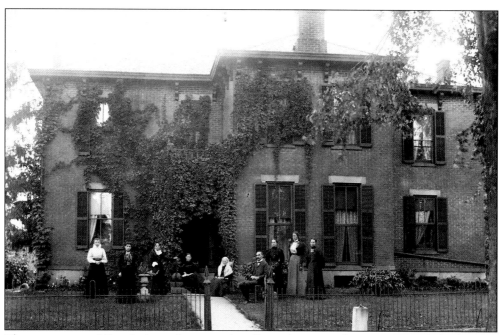

The movement of Otterbein professors and staff members into the community helped in the development of the residential areas of Westerville. This home on North State Street was owned by Dr. George Scott, Otterbein professor and president. He is pictured surrounded by the female members of his household. He later built another large home on Plum Street.

An older and smaller example of a home built by an Otterbein professor was this home built by Dr. Henry Garst on West Park Street. Garst, an Otterbein graduate, was hired to join the faculty in 1869 and built this home with its distinctive gingerbread trim. The plain adjoining building held his office and study. Garst worked diligently in his study and wrote an early history of Otterbein.

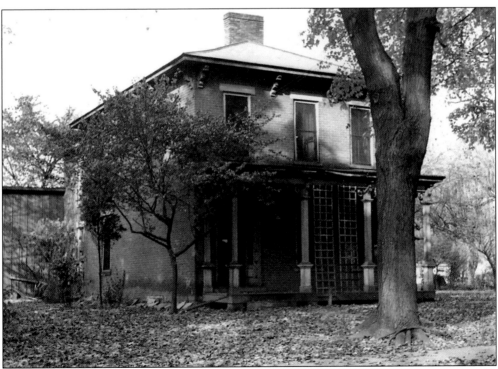

This home on West Home Street has the distinction of being the only residence in Westerville privileged to host visits from two United States presidents. Owner Mary E. Lee was very active in Republican Party politics. She hosted Warren G. Harding and later Calvin Coolidge at social events in her home. President Harding appointed her Westerville's postmistress. The rumor that she served alcohol at soirees in her home created quite an uproar in the sober community.

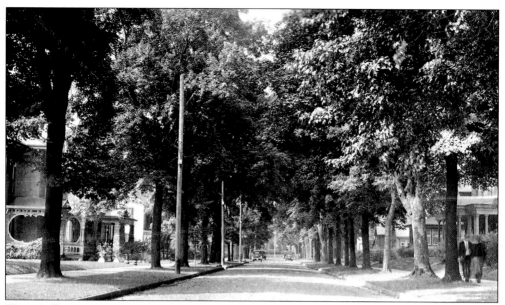

West College Avenue, pictured here with Towers Hall in the background, attracted strollers on its sidewalks. The street was shaded by a broad canopy of trees. Just a block off of busy State Street, it retained its quiet, family-friendly appeal. The residential neighborhoods surrounding uptown continued to spread in the later years of the 19th century and into the early years of the 20th century.

This residence designed by Frank Packard, architect of the Vine Street School (Emerson), is another example of a community home sacrificed for progress. The Otterbein Campus Center now stands on this site. The youngster in this photo is Mary B. Thomas happily posing with her Go-cycle. Miss Thomas was a prominent civic leader as an adult and served the community in many capacities.

The white brick Irwin, Fullerton, Teeter, Davis home at 135 East Walnut Street had a parade of interesting residents and guests passing through its doors. It was a farmhouse in the country when it was built by Samuel Irwin at the beginning of the 20th century. The house had five rooms down and three rooms and a bath up. The rooms were all large. In 1917 the Rodenfels bought the property. Mr. Rodenfel would drive into Columbus every day in his Model T and would farm the adjoining land when he was home in the evening. The Rodenfel family would hold square dances in the 22-foot square kitchen. The family had a player piano, which the children in the family would take turns operating. Hugh Fullerton, a famous sports writer, moved into the house when he came to the area to work at the *Columbus Dispatch* in 1930. He was noted for his series of articles that uncovered the scandalous fixing of the 1919 World Series. The Fullertons renovated the house to achieve an English country style of home. When renovations were completed, the home had ten rooms, two baths, a sleeping porch, outside laundry room, and several porches, including a glassed one for winter use. The Fullertons entertained famous sports figures and newsmen in the home. The next owners, the Teeters, leased the home in 1937 and entertained a steady stream of notable literary figures including Carl Sandburg. In 1953 Dr. Bill Davis and his wife Mary moved in with their four children. The grounds were perfect for the busy family and their sheep, goats, donkeys, and ponies. In 1986, they sold the house and land to the Westerville School District.

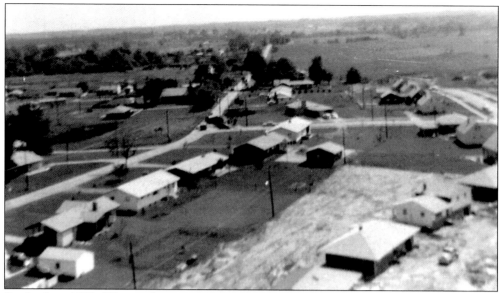

By the late 1950s Westerville was starting to experience what would prove to be an era of phenomenal growth. This aerial photo, taken in 1958 from the water tower on Otterbein Avenue, showed new houses being built just southeast of uptown. By the summer of 1959 more than $1 million worth of new homes were under construction in the community.

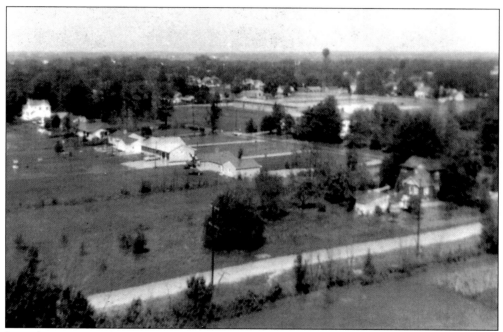

In 1959 two major housing developments were announced. Huber Development announced the construction of 2,000 homes in the Westerville vicinity. Nationwide purchased the Hislop farm west of town and announced plans to construct more than 500 homes in a development named Annehurst. The city council annexed the land under development. This photo taken from the Otterbein water tower shared a vista of fields and undeveloped land. The scenery would change in the years to come.

Dr. Isaac Newton Custer and his wife relaxed on their porch surrounded by potted plants at their home on West College Avenue. Dr. Custer, local dentist and cousin to General George Custer, represented a Westerville where life was quiet and genteel. Socializing with neighbors, family, and friends provided the major source of entertainment for many residents in the latter years of the 19th century. The Custers were dressed formally and ready for visitors.

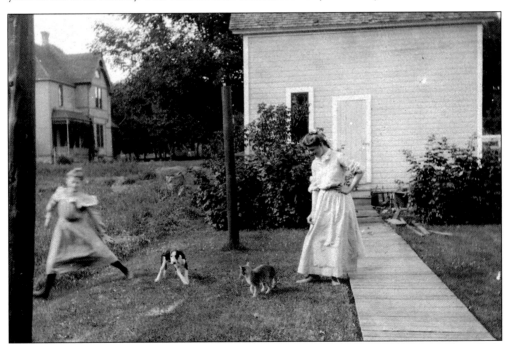

Growing up in Westerville provided a lot of opportunities for play for children. The whole community was a playground, from the swimming holes on Alum Creek to the Bishop sledding hill. The whole community acted as surrogate parents. If a child got in trouble with a neighbor or at school he was certain to get in trouble at home. Everyone knew everyone in the small community.

The Whitney sisters, Edith and Judith, are typical of children who grew up as part of the Westerville community and chose to live their adult lives in Westerville. Pictured in front of their parents' home on North State Street, the girls continued to live at this location until their deaths.

These young men are playing delivery service in the cart of the Wolf Rapid Delivery Service in the early 1920s: R. Richardson, the chauffeur; Max Sowers; Boyd P. Doty Jr.; and his cousin. Many young people had real employment in the community. Paper routes were popular with young men. Young women babysat and did light housework or laundry for their neighbors.

Westerville residents also liked to go to the countryside for entertainment. One of the favorite picnic grounds was along Big Walnut Creek. Wagon loads of Westerville young people would travel east for a day-long picnic along the rocks of the creek. The Woodmen of the World organized a chopping party in February 1900. Sixty-five men joined in the activities. The men tackled taking down two walnut trees, and after the mission was accomplished supper was served. The wood was cut into logs just the right size to fuel a stove.

In December 1921 an even more interesting event took place. The day after Christmas that year, at 10:00 in the morning 2,500 people lined up around a 40-square mile stretch of countryside. The lines slowly began to move toward the center of the square. No autos were allowed—it was strictly foot power. No dogs or guns were allowed—only clubs. The purpose of this gathering was to hunt fox. The captured animals were then auctioned off to raise funds. Three foxes were captured, only two alive. Interestingly enough, accounts of the hunt admit that seven fox escaped the human dragnet. The bonus catch was a dozen rabbits snared, as well as a skunk. This valuable bonus was auctioned for four dollars. The only mishap in this hunt without guns was a fox bite on the hand of one of the participants.

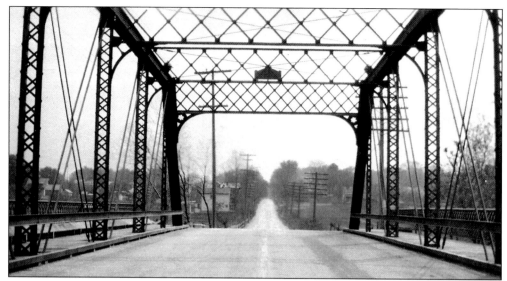

In Westerville one of the popular activities for young people was to take a leisurely stroll on what was affectionately called "the four mile." Beginning in uptown, strollers would meander out Main Street across the bridge to Cleveland Avenue. At Cleveland Avenue they would turn left and walk through the countryside until they reached Schrock Road. Another turn to the left had them heading east toward State Street. Upon reaching State Street and Schrock they began the final leg of their journey back to where they began.

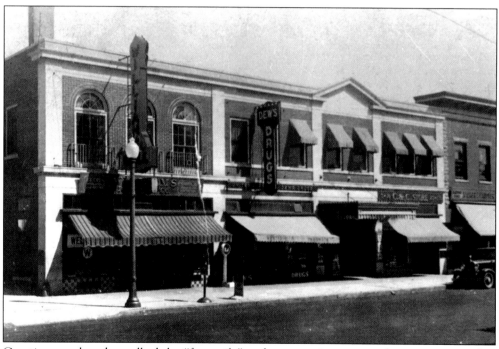

Courting couples who walked the "four mile" and were anxious to spend more time together would frequent either Dew's Drugs or Williams Grill depending on their spare change. Dew's was the cheaper alternative. The soda fountain at Dew's was a popular hangout for the teen crowd. It was especially economical if a single coke or soda was sipped through two straws.

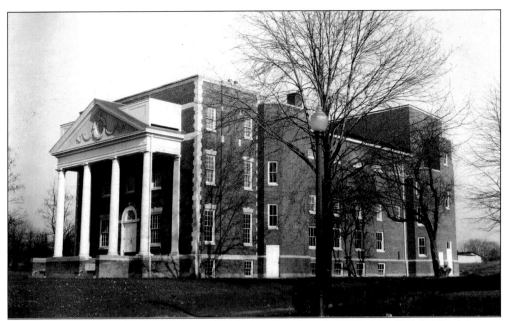

Civic and fraternal organizations have played an important role in Westerville life. The Masonic Temple constructed on South State Street in 1929 represented an impressive commitment by the Masons in the community. The current lodge was founded in 1862 and continues to be a part of the city.

The Blendon Grange is another example of an organization that has been part of local life for over a century. Organized in March 1874, the Grange in Westerville was organized for the betterment of the farmer and through the years undertook many projects to aid neighbors and the community. Members met in locations throughout the community until 1956 when they built a Grange Hall on East College Avenue. This photo was taken at a Grange dinner in 1957. John Tepper is the waiter in the foreground.

As the village entered the 20th century, a group of local women founded the New Century Club. Organized to promote intellectual literary study, membership was by invitation and considered an honor. A different theme was chosen annually and presentations centered on the theme were given at meetings in members' homes. This photo was taken of the 1940 officers. Pictured from left to right are: (front row) Mrs. J.R. King, Mrs. Ella Scofield Harnett, and Mrs. A.P. Rosselot; (second row) Mary B. Thomas and Audrey Earl. The club continues in existence today.

Founded by Mrs. J.A. Weinland and Mrs. T.J. Sanders, the New Century Club first met October 8, 1900, and the topic for that first year's study was "Our Country." The ladies proceeded to select the carnation as club flower and green and white as club colors. They also decided to pay to have a program printed. Loyal members stayed in the group for decades, and later their daughters joined. This photo was taken of Halloween party decorations for a New Century gathering in 1904 at the Whitney home.

One of the organizations in the community that welcomed male and female members was the Westerville Garden Club. Organized in 1948, the club had annual flower shows and promoted beautification projects. Mrs. W.S. MacKenzie and Mrs. Robert Pulley prepared for the annual flower show in 1956. The theme of that show commemorated the 100th anniversary of the publication of "Darling Nelly Gray."

These men prepared for the 1956 flower show in one of Westerville's ornately landscaped backyards: (left to right) R.A. Hodgden, Charles Bennett, Robert Short, and Robert Pulley. The 1956 flower show was held on the Otterbein campus. Displays depicted various aspects of Ben Hanby's life and music and a replica of the Hanby House was part of the exhibit. The garden club also sponsored garden tours to allow local gardeners an opportunity to share the results of their green thumbs.

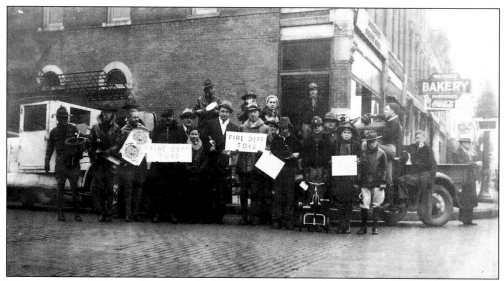

The citizens of Westerville have displayed their philanthropy through all types of civic organizations and fund-raising drives. In 1935 Boy Scout Troop 39 collected toys to deliver to needy children in an effort to make their holidays brighter. During the Depression many projects were undertaken in an effort to help the needy. The firemen also collected and repaired used toys for distribution. The PTA organized a surplus canning project and clothing drive. The American Legion Auxiliary served hot lunches to school children.

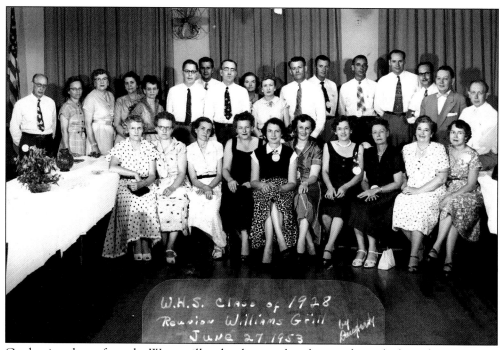

Graduating classes from the Westerville schools were close-knit in the early days when everyone in town was acquainted with each other. Reunions for the classes were a popular activity with everyone anxious to see their old classmates and share memories. The class of 1928 met in the Williams Grill crystal room for their 25th class reunion in 1953.

Play productions were very popular with the residents. Traveling companies came to town to entertain and local citizens formed their own civic theatre groups. In 1925 this costumed cast presented "Seven Keys to Baldpate." The play was produced by Post 171 of the American Legion and directed by Horace W. Troop. Cast members were, from left to right: (first row) H. Heischman, Florence Schrock, B. Palmer, M. Conard, L. McLeon, and D. Conrad; (second row) J. Ranck, C. Hunt, H. Elliott, Daniel Main, unknown, H. Collier, D. Cartright, J.C. Caris, G. Hunt, G. Longhenry, D. Schrock, A. Troop, and Horace Troop.

This "who's who" cast of prominent Westerville citizens was part of a theatrical production of "Harvey" staged at Otterbein. Pictured, from left to right, are: (standing) Marguerite Tucker, Melvin Clapham, Jane Bradford, Robert Snavely, Melba Clapham, and Dr. Holdren; (sitting) Mabel Dustin, John Wells, and Mary Meyer Newton.

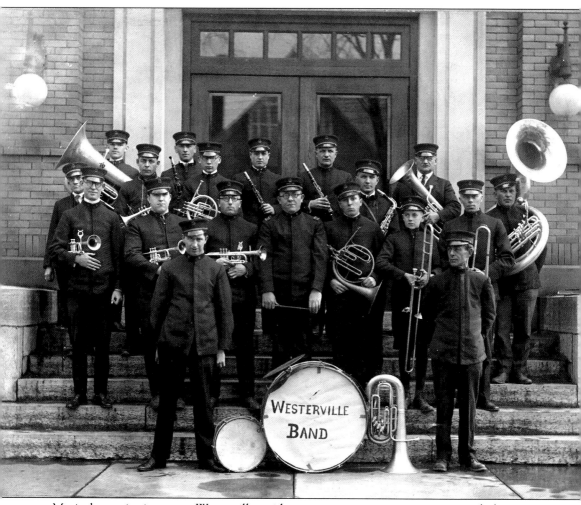

Musical organizations gave Westerville residents an opportunity to appreciate and play music. Otterbein encouraged this with musical productions on campus that attracted the townspeople. The Otterbein brass band enlisted in its entirety during the Civil War. Many years after the war, the D.H. Budd Cornet Band began to entertain and march in local parades. Locally sponsored, the band allowed residents to have an outlet for their musical creativity. Several other civic organizations recruited members and others to play. In 1919 a new band was formed. They provided weekly concerts for their fellow citizens with reports of as many as 400 listeners. One of the early members described the hard work the band had to do just to have a stage. On Tuesday evenings when their concerts took place, the band members would have to set up a stage in front of the bank. Their timing was important because they would put up the stage on the trolley tracks. They would wait for the 7:30 p.m. trolley to pass, pull out sawhorses and planking that rested on the sawhorses, put the makeshift stage together, play their concert, and disassemble the platform before the 8:30 trolley moved through. Because the musicians were popular, the merchants took advantage of the influx of people uptown and stayed open later. The band uniforms consisted of trousers supplied by the musicians and red and blue coats and hats provided for them. The band disbanded in 1936. As they recruited individuals from surrounding communities to join them they began to have difficulty scheduling practices with good attendance. They rarely marched in parades, but on the occasions when they did they were a hit. They are pictured here.

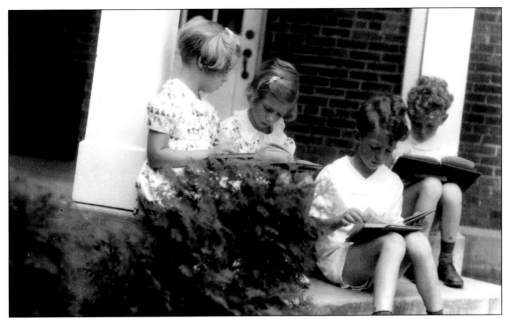

In 1930 Westerville formed its first public library. Parent groups led the drive to bring the library to the community. The first public library was located in the Purley Baker home on the southwest corner of Grove and Park Streets in space loaned by the Anti-Saloon League. These young people are sitting on the steps of the library after it was relocated to the second floor of the city building on South State Street in 1933.

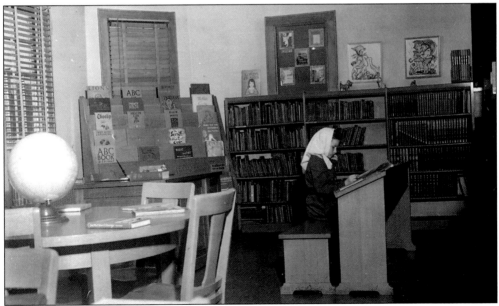

The Westerville Public Library was an immediate hit with the community. Cora Bailey, a bereaved mother, was beseeched by local residents to become the library's director. The library has only had four directors since its formation. This young reader was just one of the residents who made the library one of the busiest places in town. In the first 13 days of operation in 1930 the library had 885 borrowers and loaned 3,062 books.

As usage of the library escalated and the space on the second floor of the city building became stretched beyond capacity, the library placed materials in space at the high school across the street. When that space was needed for classrooms, the library became so crowded that all storytimes and other programming were discontinued. As a temporary solution, 6,000 books were moved to a room at the Masonic Temple. Then in the early 1950s a bond issue was passed to pay for this building.

Located at 126 South State Street, the new library building was constructed on land donated by the Anti-Saloon League. The library and the league were neighbors at this location. Dedicated in March of 1955 in its new location, it found opportunities to bring new services to the public. In 1958 a bookmobile was purchased to serve residents and schools. The Anti-Saloon League building is now part of the library and houses the photographic archives used in this book.

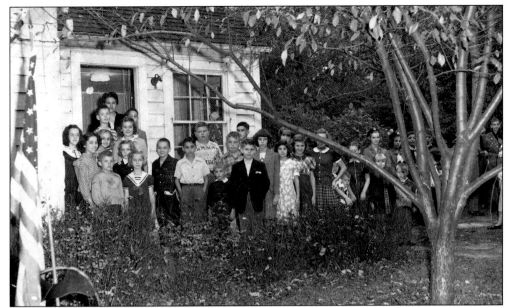

In 1950 local citizens in this family-oriented community founded their own children's museum—the Hanby Junior Museum. Located in the small cottage behind the Hanby House, the museum had varying exhibits and free admission. The exhibits drew an audience of children and adults. Memberships sold in the community helped fund the enterprise and the local chapter of the American Association of University Women took a leading role.

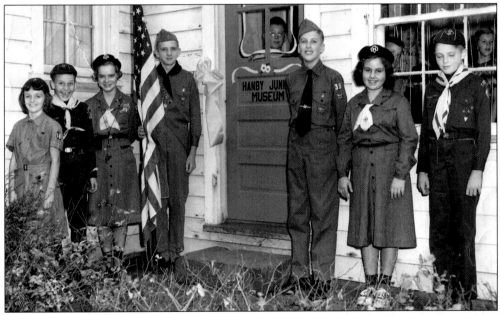

These school children are preparing to visit the museum. The boy holding the flag is Alan Norris, later a federal judge. The museum had exhibits on loan from other institutions with the text written on a school age child's level. In order to maximize the use of the facility, art classes and story hours were held on the premises with the help of Otterbein and the public library. The museum closed in 1958.

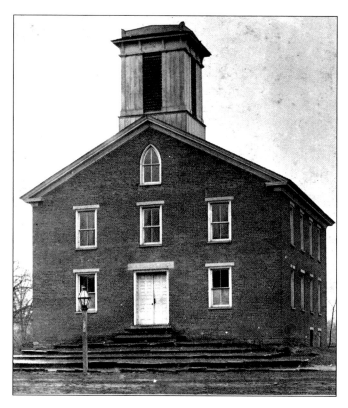

Westerville's early pioneer families brought their faith with them to this undeveloped land. In the early days of the community the settlers met in each other's homes for worship services provided by circuit riders. The two main denominations were the Methodists and the Presbyterians. The Westervelts and the Sharps were early contributors to the building of this church—the first of three Methodist church buildings on the same site on North State Street.

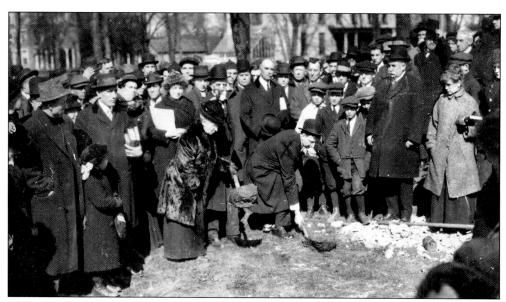

With the founding of Otterbein, the United Brethren Church became an important part of the community. Until 1916 the congregation met in space loaned by the college. This photo was taken at the ground-breaking for a church building for the congregation. The new church—Church of the Master—still stands across from the campus at the southeast corner of Main and Grove Streets.

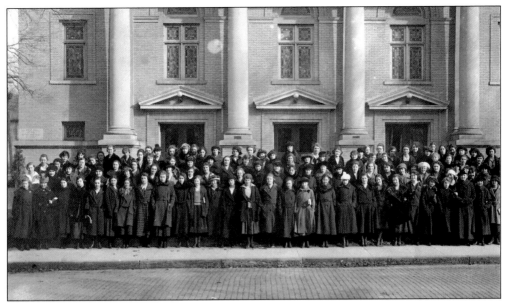

The community's churches provided social contacts that lasted a lifetime. Many young people met their spouses in church. Sunday school classes were held for all ages. Women had their church circles to bolster their social and spiritual life. In times of need during the Depression the churches helped serve hot meals and allowed their kitchens to be used for canning parties. Church of the Master is pictured here.

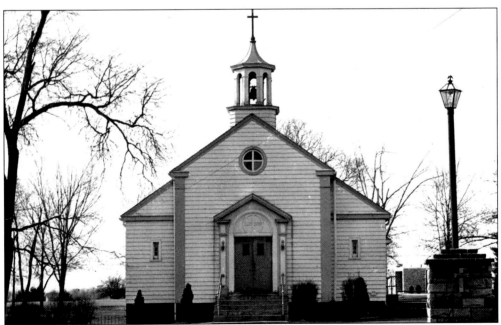

Westerville was predominantly Protestant throughout its early years. In 1913 a couple of rooms were rented on State Street and Catholic mass was celebrated for the five families in the parish. Before that, families went into Columbus for mass. In 1931 this church was built on North State Street. In 1961 an elementary school was opened to serve the needs of the growing congregation, and by the late 1960s over 450 families were members in Westerville's Catholic parish.

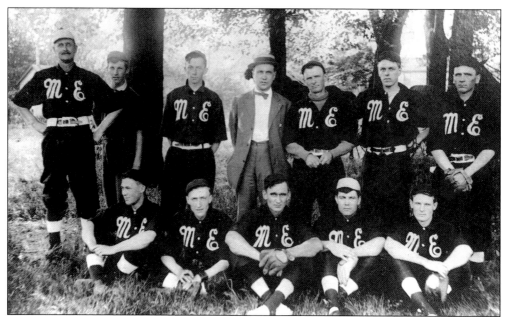

In June of 1888 the local newspaper reported that the "baseball craze" had hit the town. The fire company organized a team, and a group of young men calling themselves the Westerville Amateurs challenged them to a game as part of a picnic outing at Black Creek. The outing to the creek required 12 wagons to transport all of the players and their eager supporters. A dispute disrupted the game. When replayed the final score was 36-8 in favor of the fire company. This church team played in 1902.

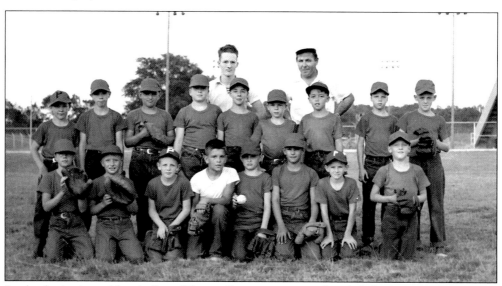

In the beginning of baseball in Westerville, games were played daily. Teams of boys from different sections of town organized impromptu games. The hastily chosen teams of yesteryear are gone. In 1909 businessmen requested that church league games be held on weeknights because Saturdays were busy days for them, and they would not be able to attend. In more recent years organized sports activities filled the local fields on weeknights and weekends. Ernie Ernsberger, far right in the back row, coached this group and posed with them for the camera.

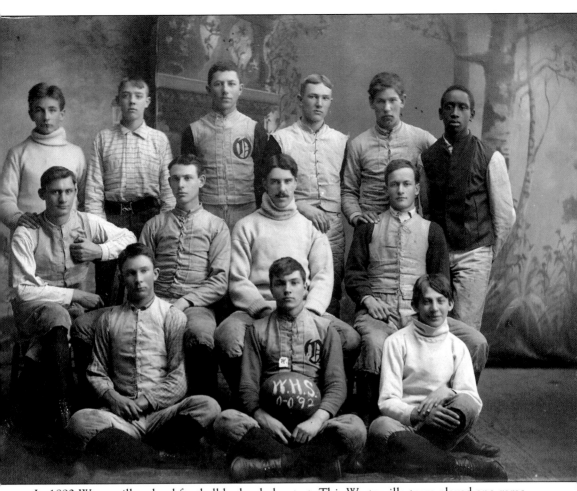

In 1892 Westerville school football had a shaky start. This Westerville team played one game. They were organized to play a game against Otterbein's prep team. The result of that conflict was a tie. The game was rugged and blood was spilled. The following year a catastrophe happened that resulted in the banning of school football for eight years. Superintendent of Schools Ed Ressler, who also played on the football team, broke his leg during a game. No high school football was played again until 1901. That year and the next, the school fielded a football team but, based on concerns of parents, football was deemed to be too rough and was banned. It reappeared in 1921 with Dave Parks as coach. The team's record was 1-1-4 playing against teams like the Methodist Church Sunday School team (they tied). The team practiced on a pasture on East Park Street. Home games were played on Otterbein's field. Football protective gear was scarce. Pictured here are the 1892 team members, from left to right: (top row) G.H. Hershey, W.M. Dubois, F.H. Everal, C.C. Hutches, Stanton Gantz, and J.W. Fouse; (middle row) W.M. Gantz, R.A. Rice, Superintendent Ressler, and O.C. Neiswander; (lower row) LeRoy Merchant, C.T. Click, and C.L. Beatty. Even though this team had a losing season they more than made up for it with colorful nicknames and interesting post-school careers. "Speck" Hutches ran a celery farm in Manatee, Florida; "Pinky" Rice became the head anaesthetist at Grant Hospital; and "Rubber Legs" Gantz left for the Klondyke gold fields in 1898 and was never heard from again.

On September 14, 1929, the privately owned Glengarry Pool was dedicated and formally christened with an audience of 200. Miss Helen Dailey, elected the most popular girl in Westerville, was granted the privilege of christening the new pool. After some remarks by dignitaries, Miss Dailey dove into the cold water and swam to the diving platform in the middle of the pool. In her hand she clutched a vial containing the purest of water distilled in a laboratory at Otterbein and upon reaching the platform she emptied the vial into the pool. On that windy chilly day a new recreational opportunity was opened for Westerville citizens. The pool was built on land owned by the Dempsey family and purchased by community leaders. The 7-acre plot was financed by the sale of $10,000 worth of stock. Two wells were drilled and water was run through a series of filters before being released into the pool. The water was changed every 12 hours giving the pool its slogan "Swim in water fit to drink." The pool was circular in shape with a 138-foot diameter. The platform in the center had four diving boards and water was its deepest, 9.5 feet, near the boards. The pool could hold up to 1,200 swimmers. During the Depression Mondays were nickel day at Glengarry. Youngsters would save so they had the funds to be able to pay for the privilege of swimming all day for 5¢.

Before the construction of Glengarry Pool young people in the community swam in Alum Creek or in Big Walnut Creek. Alum Creek had two swimming holes—one for boys and one for girls. A great sycamore tree on the banks of Alum Creek with branches reaching over the water had boards nailed to its trunk to form a ladder and served as a primitive diving board at the boys' swimming hole.

In 1958 the Westerville Jaycees raised the funds to build a pool in town on Otterbein Avenue. By 1962 they had expanded the complex with a second pool. Rather than in earlier years when Westerville teenagers hitchhiked back and forth between their homes and Glengarry Pool, they could now ride their bikes or walk to the convenient complex. The construction of the Jaycee Pool is another example of a civic organization working to make Westerville a better place to live.

The municipal park developed and built during the Depression on the banks of Alum Creek was a popular gathering place for teens and families. From the time Alum Creek served as a swimming hole for boys and girls and canoe trips were a courting ritual, the creek provided recreational opportunities for residents of the town. These young men take advantage of the shuffleboard court to pit skills against each other.

A wading pool, playground equipment, shuffleboard courts, picnic areas, and the amphitheatre drew residents to the municipal park. The Depression-era laborers also built a log cabin on the grounds of the park. These young people roasted their dinner in the fireplace of the cabin.

In 1941 the Westerville Matinee Club built a race track on Hempstead Road on land owned by the McVays. The track was used on Sundays and holidays. The 4th of July holiday was the most important day of the year for the area's horse racing fans. There was a refreshment stand at the side of the track, and people brought their own picnic lunches from home to tide them over during the all-day event. There was no admission charge, but the hat was passed to help defray the costs of up-keep on the track. At times the hat collection netted as much as $100. Local businesses helped with the events. The Westerville Creamery furnished a water truck to wet the dirt track to keep the dust from blowing around. The racing events attracted a lot of attention and audiences that could number as many as 1,500 on a day. During World War II it was the site of war bond sales. Local merchants would donate prizes to be awarded in this war support effort. The McVays owned race horses and were important supporters of the racing community. They also were philanthropists donating funds to many worthy causes in Westerville. By 1945 the community lost some interest in the racing events, and the track ceased to be used for the community-wide gatherings.

Through the years Westerville residents traveled away from the town. They went by buggy, train, and trolley to visit family and friends. Most did not travel far. Miss Helen Moses, long-time public schoolteacher and considered one of the most cosmopolitan women of the town, was an exception. In the 1920s she traveled to Europe. She posed in the Alps with companions during her grand adventure aboard.

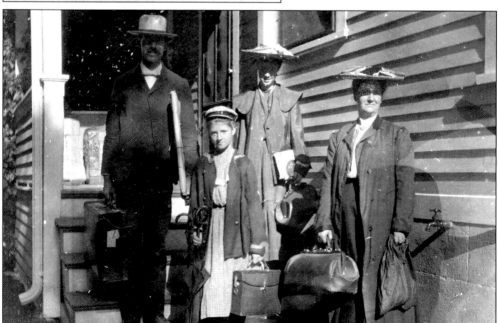

The caption on the back of this photo states, "Home at Last Aug. 6, 1904." Westerville residents might leave the community for extended periods of time, even decades, but the "quiet peaceful village" stayed in their hearts and minds. Those who moved away kept in touch with old friends through correspondence and found reasons to visit and in many cases even moved back to Westerville.

The Civil War took quite a toll on the community. Three hundred men from the town and surrounding area served in the army. Many Otterbein students joined as well as many other residents. William Headington, whose stone memorial is in the Old Methodist Cemetery, was married to a Westervelt and ended his war experiences in the horrific Andersonville prison camp. Other local boys suffered similar fates through battle and illness contracted while in the army.

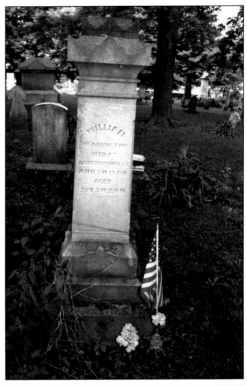

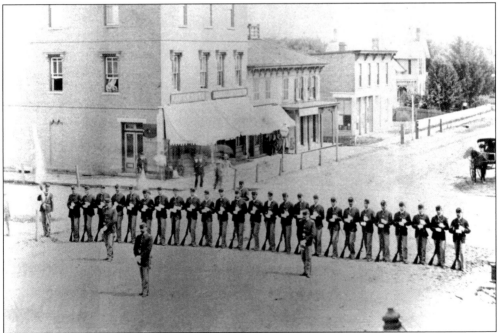

After the Civil War veterans returned home and felt the need to connect with fellow veterans in their communities. The Grand Army of the Republic James Price Post was chartered in June of 1883. Price was killed in the last charge at Nashville Tennessee in December 1864. His brother Warrick also died in battle. The G.A.R. gathered at the intersection of College and State.

TAPS
AT 4:30

Beginning at 4:30 this afternoon and continuing until the war is over, C. W. Ackerson will sound taps on his bugle. Every person at that hour is expected to cease work or other occupation, bare the head and stand in prayerful attitude, with head slightly inclined, and engage in silent prayer for a moment. If you cannot hear the bugle, go by the clock. Pray for our nation and its soldiers, our allies and their soldiers, and the success of the common cause.

Listen for the Bugle
Watch Your Clock

(*above*)Westerville residents, including some of the first settlers, volunteered to serve in the Revolutionary War and also in the War of 1812. As the community grew after the Civil War, there was a concerted effort to honor those who had served. The first official observance of Decoration Day in Westerville was in 1878. Citizens honored those who had served with parades and celebrations. In 1882 on the Otterbein campus these young people, bedecked with red, white, and blue, served as waiters at a banquet reuniting Civil War soldiers.

(*left*) Westerville sent 130 men to serve during World War I. Two young soldiers died overseas in France: Curtis Young of influenza and George J. Budd of meningitis. Because of their sacrifices, the American Legion Post 171 in Westerville was named the Young-Budd Post. The citizens anxiously anticipated the end of hostilities overseas, having taps played everyday from October 1, 1918, until the armistice was signed. At the announcement of the war's end the citizens took to the streets in a spontaneous celebration.

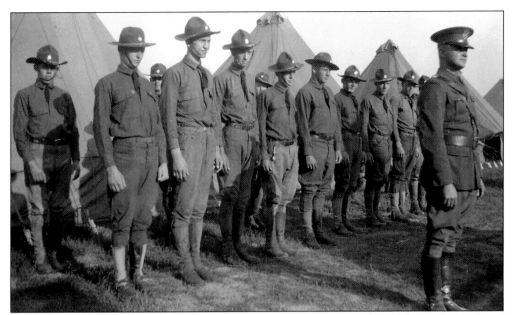

These men were members of the 134th Ambulance Company—a National Guard unit based in Westerville. Organized in 1921, the 112th medical battalion, which the unit belonged to, saw action in the Pacific Theater in World War II and also saw action in Korea. Lined up for inspection, these men are taking part in training in the 1920s.

During World War II the citizens supported the war effort and their boys overseas. This window display in an uptown business urged residents to purchase United States savings bonds. Five hundred and eighty-three men from Westerville served in the armed forces including 12 nurses and 12 women. At the end of the war when the troops returned to town, a housing building boom hit the community.

In the early 1880s telephone service came to Westerville. In the beginning it was a rather haphazard operation with individuals stringing lines between their businesses and other businesses. But gradually the town was connected with other towns through this new form of communication. Several companies had franchises through the early years of the 20th century. These women worked for Ohio Bell.

Westerville, Ohio, Aug. 2, 1941 No. 2

The telephone company was located on the second floor of the Weyant Building for many years. These women worked the switchboard that was the hub of the communications network. They handled the emergency calls by sounding the fire siren with a switch and by turning on the police alert—a red light bulb next to the traffic light at State and Main. The operators are, from left to right: Elmetta Wildermoot, Marie Secrest, Mabel Richardson, Gladys Yantis, Belva Fravel, Marguerite Bagley, Jane Hessler, and Gladys McLeod.

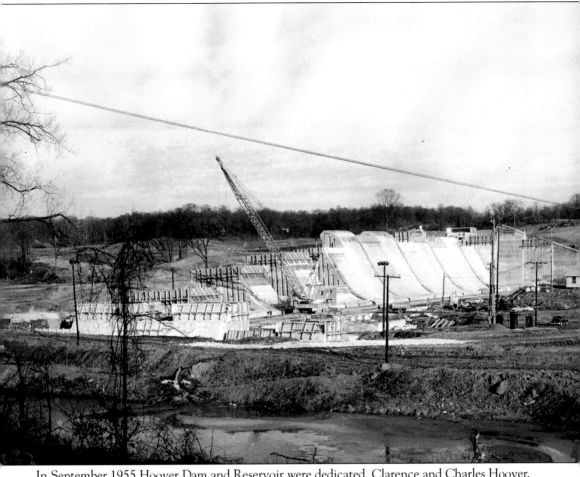

In September 1955 Hoover Dam and Reservoir were dedicated. Clarence and Charles Hoover, brothers who both served as water superintendent for the city of Columbus, were honored for their vision and perseverance in bringing the project to fruition. As early as the 1920s they dreamed of a new way to ensure an adequate water supply for Columbus. In the 1930s they turned to Big Walnut Creek to look for solutions and began to measure rainfall around the creek. Severe drought conditions in the 1940s and the freezing of the watershed in 1945 forced Columbus to turn to the studies of the Hoover brothers for solutions. It cost $25 million to build the dam and the water treatment plant downstream. It created a lake 8.5 miles long and in some places 80 feet deep. It changed the landscape forever. Farms and homes in the path of the water and construction disappeared forever as bulldozers moved 712,000 cubic yards of earth, and water gathered behind the completed dam flooding the land. The dam helped Columbus solve its water problem for a while and provided recreational opportunities for Westerville residents who boated on the new body of water.

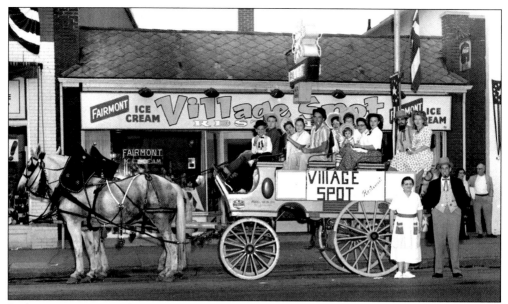

Pride in community culminated in 1958 when the town held a huge celebration to mark the 100th anniversary of the chartering of government in Westerville. Months of planning by citizens and business leaders produced very memorable festivities. Eight days of celebration featured something for all ages and plenty of costumed residents. These celebrants posed at 33 North State Street on a wagon advertising the Village Spot, the business in the background.

One of the most popular events of the Centennial celebration was the parade. The uptown area was packed with residents who came to view each other's costumes and the 100 parade entries. A dozen bands provided music; marchers sprayed the crowd with water from an antique fire wagon; vintage cars and buggies drove up State Street together; and floats representing every organization in town were bedecked with historic themes. One float even had company representatives passing out miniature ham sandwiches to the gathered crowd.

During the summer of 1958 organizations named "Brothers of the Brush" were committed to fostering beard growth and enthusiasm for the August celebration. These celebrants with hats off honored the passing of "Mr. Safe T. Razor" as part of their commitment to being unshaven. Men dressed as Keystone Kops hauled off those who showed up on the streets of Westerville clean-shaven and fined them. A contest with categories for the best types of facial hair growth culminated this part of the celebration.

An elaborate pageant titled "Trails 'N Turnpikes" presented the centennial celebration organizers an opportunity to tell the story of the community through drama. Nightly performances featured 300 cast members. The fire department built the stage and Sanders Frye of Otterbein built a replica trolley car. The James Wolverton family posed for this photo in their Westerville Centennial finery.

On January 5, 1961, Westerville officially became a city. Population had grown from 4,121 in 1950, to 7,011 in 1960. The citizens were demanding more and better services. Westerville was one of the first communities in the country to fluoridate its water supply. Major sewer repairs and construction were undertaken to help offset the demands because of new construction.

This aerial photo was taken in 1961. The farmers' fields still dominated the landscape, but change was on the way. The first Westerville shopping center opened in 1960, and Edwin "Dubbs" Roush was one of the businessmen who committed to this new risky venture. It proved very successful. Other retail shopping centers at the corner of Schrock Road and State Street followed. The unprecedented growth of the next four decades was just beginning in Westerville.